THE ART OF
RUPERT GARCIA

THE ART OF
RUPERT GARCIA

A Survey Exhibition

August 20–October 19, 1986

Text by
Ramón Favela

Chronicle Books
and The Mexican Museum
San Francisco

The Art of Rupert Garcia
August 20–October 19, 1986

The presentation of this exhibition is made possible with generous support from Las Amigas del Museo and the National Endowment for the Arts.

The programs and services of the Mexican Museum are supported, in part, by grants from the San Francisco Foundation, the San Francisco Hotel Tax Fund, the California Arts Council, and the Institute of Museum Services.

Edited by Susan Pelzer and Suzanne Kotz
Designed by Ed Marquand, Ed Marquand Book Design
Photocomposed by The Type Gallery

Photo credits: Ben Blackwell: 1, 2, 4–20, 22, 24–26, 41, 42, 45–55, figs. 1–5; Chris Huie: 21, 26; Bob Hsiang: 28; Blair Paltridge: 30, 32–37, 40, 43, 44; Lisabeth Thorlaciuf: 38, 39

Printed in Hong Kong

Rupert Garcia is represented by Harcourts Gallery, 535 Powell Street, San Francisco, California, 94108 (415) 421-3428

The Mexican Museum is located at Fort Mason Center, Building D, Laguna and Marina Boulevards, San Francisco, California 94123-1382 (415) 441-0404

Published by
Chronicle Books
One Hallidie Plaza
San Francisco, California 94102

Foreword

With great pleasure, the Mexican Museum presents the first comprehensive survey exhibition of the art of Rupert Garcia, a Bay Area artist well known for his passionate, superbly executed works on paper. Active in the Chicano cultural renaissance of the late sixties and steeped in the Mexican mural and revolutionary poster tradition, Rupert Garcia has a thorough knowledge of serigraphy and pastel painting techniques. By coupling those refined skills with an essential humanism, this outstanding artist has given us a rich body of work, which we are proud to exhibit and document with this publication.

This project reflects our institution's continuing commitment to collecting and showcasing the work of living Mexican-American artists. Its successful execution is the result of the combined efforts of many individuals and organizations. Guest curator Ramón Favela was invited to select works and write the catalogue essay, tasks he approached with enthusiasm from the start. On behalf of the museum, I wholeheartedly thank Dr. Favela, a noted scholar in the field of Chicano studies, for taking time from his busy schedule at the University of California at Santa Barbara. His professional contribution provides a fresh perspective.

Most important, we wish to thank the private and institutional lenders (whose names are listed in these pages) who so graciously agreed to part with their artwork for an extended period of time. Their generosity is helping to increase public awareness of Rupert Garcia's work.

Fred Banks of Harcourts Gallery, the artist's dealer and a long-standing museum supporter, assisted us in numerous ways. We are grateful to Mr. Banks and his staff for their willing cooperation and support.

Financial assistance crucial to the realization of this publication and the entire project came from the San Francisco Hotel Tax Fund, the California Arts Council, the Institute of Museum Services, and the National Endowment for the Arts. For their generosity, we extend our sincere appreciation to these important government funding sources.

The staff of the Mexican Museum, as always, deserves commendation and recognition for many hours devoted both to the catalogue and to the exhibition. Naturally, I extend *abrazos* to my entire support staff and, in particular, to Nora Wagner, Bea Carrillo Hocker, Gloria Jaramillo, Lorraine Garcia, and Blanca Flor Gutierrez.

Finally, I wish to thank the artist himself for his consistent good nature and enviable organizational skills. Working with Rupert Garcia is a pleasure and an honor.

David J. de la Torre
Executive Director

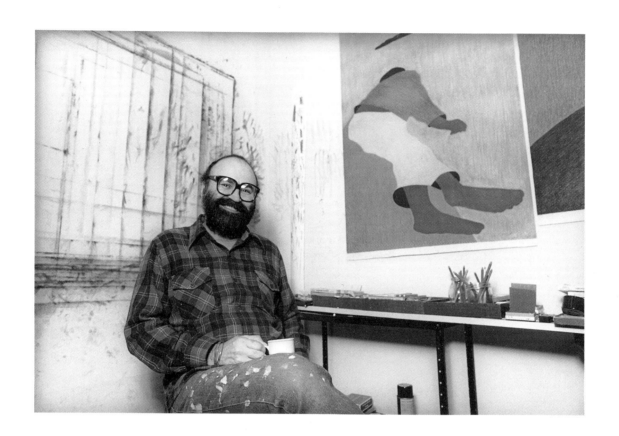

Rupert Garcia, 1986. Photo
by Terry Lorant.

The Pastel Paintings of Rupert Garcia: A Survey of the Art of the *Unfinished Man, Inside-Outside*

What began as a student strike was launched on the campus of San Francisco State College in the fall of 1968 by the Third World Liberation Front, a loose coalition of ethnic minority organizations. Led initially by black, Chicano, Latino, and Asian students, then garnering considerable faculty and community support, the strike demanded an end to racism and institutionalized violence against various nonwhite communities in the Bay Area.[1] It sought the redress of Black Studies programs, student rights, and a reassessment of the teaching methodology at the college. The admission and retention of Third World students—meaning all people of color attempting to get a higher education at the institution—and the curricular development of La Raza studies were also high on the list of demands.

Rupert Garcia studied art at San Francisco State College (now University) during the throes of the strike, an experience that held untold consequences for the political and artistic future of the then young artist. In this essay I will concentrate on this and other formative elements in Garcia's artistic and ideological development, placing his powerful works in the recent historical context of certain cultivated myths in American art and society.[2] This intense, socially committed, and intellectually sophisticated artist has reached a flourishing midcareer, creating with vibrant color contrasts, strong lines, and profoundly engaged subject matter what Peter Selz has described as a "new shudder" in his recent works. These qualities have placed Garcia firmly on the international spectrum of the newly revitalized medium of pastel painting.[3]

This seventeen-year survey exhibition begins with a rare acrylic painting titled *Unfinished Man* (1968). The painting was done two years after the artist's return from military service in Indochina and during his art studies at San Francisco State. According to the artist, the source for the image was a photographic reproduction of an unknown black man, a newspaper clipping; one of many from the artist's growing "picture morgue." Placed starkly against a thinly painted field of evanescent sky blue, the man's head, mouth half-open in the pain-ridden gesture of an impending scream, has been dramatically and radically cropped. To the question "In what way is the man unfinished?," Garcia responded: "Well, the condition of racism made it [in 1968], makes it today, still, very difficult for black people and other oppressed people to feel complete, to fulfill their human potential. That's what the picture is about, a human 'unfinishedness' that has been imposed."[4]

Unfinished Man expresses the artistic concerns and social commitment of Rupert Garcia that continue to this day. From his earliest works to his latest, Garcia has explored the mass media as a producer of stereotypes and the popular interpretation of iconic images in contemporary society. When queried about these concerns as reflected in his mature works, Garcia recalled that "As far as I can remember, I have always been interested in referring to images that already have built-in to them an audience, be it thousands who look at the photographic reproduction in the *San Francisco Examiner*, be it millions who see it in *Time* magazine." Garcia set out to reinterpret selective mass-media images personally, with the full knowledge that their public meaning might be open to

various interpretations. At second best, they might be seen only as political propaganda, and at worst, the point might be completely missed, as was the case with a critic of his early works, who, when commenting on Garcia's "gifted draughtsmanship," viewed his "early representational style [as] simple, clear, and appropriate to an interior furnished by Design Research."[5]

Initially, the artist responded to the mass media's representation of Third World peoples, its creation of racial stereotypes, and its images of oppression, police state violence, and psychological, social, and physical torment. Increasingly, political martyrdom, murder, and mayhem became major preoccupations of his work. These themes were solidified ideologically and theoretically by the mid-seventies, when he began his large-scale pastel paintings, such as *Political Prisoner* (1976) and his portrait of the slain contemporary Mexican revolutionary *Lucio Cabañas* (1976), ambushed and killed in the hills of Guerrero state in Mexico by government forces in 1974. The pastel, his first major painting executed solely in that medium, was based on a photograph of Cabañas published in the Mexican popular magazine *Alarma*, one of many that specializes in graphic reproduction of the most sensationalist scenes of gore and violence. The enlarged face with strong Mexican-Indian features appears almost angelic in Garcia's transformation. The variegated browns and ochres are carefully and uniformally hatched in divided, directional strokes of pastel pigments, evoking a veil of centuries-long sorrow descending slowly across the broad expanse of the expired leader's face. Another chilling work, his global journalistic composite entitled *Mexico, Chile, Soweto...* (1977) is, unfortunately, almost a decade later still a pertinent response to South Africa's abhorrent system of apartheid.

Garcia's self-motivated discovery of Mexican art and culture as an assertive alternative to the European and American art traditions on which he had been schooled was fomented by his participation in the 1968 student strike. In particular, the Mexican muralists and graphic artists about whom he read and whose works he studied in illustrated books revealed to him that art in the service of a political as well as a cultural revolution was not only possible, but a personal imperative for him as a fledgling Chicano artist with a growing social consciousness. He would not view many original works of Mexican social realist art until his first trip to Mexico City in 1973. But, in 1968, Garcia began to see a use for his art on the cutting edge of a momentous social change in American society. In that same year he abruptly gave up acrylic painting (returning to the medium on one occasion to pay homage to *Ruben Salazar* in 1970), turning his energies to producing silkscreen posters and serigraphs exclusively for the next seven years.

The artist also included in his repertoire of source images the portraits of well-known artistic and political celebrities of our time as disseminated by the mass media or art press. He chose his subjects carefully, composing their portrait images for very specific symbolic or ideological reasons. At first view, Garcia's portraits based on famous reproduced images, such as the widely circulated photograph of Picasso that served as the mediated source for three of his Picasso portraits in this exhibition, might appear to be simple takeoffs on the media-elevated cultural icons of the twentieth century, products of the glamorous big sell. Iconic images of such universally recognized artist personalities as Picasso, Frida Kahlo, Diego Rivera, Siqueiros, Bertolt Brecht, Luis Buñuel, and George Orwell, or the relatively well-known, unconventional artists Goya and van Gogh, are all based on mechanically reproduced photographs or published self-portraits of the subjects. However, being subversives of exhausted artistic traditions or corrupt institutions in their own right, their

emblematic images were selected in the seventies and early eighties by Garcia precisely for the implications of the political sympathies held by these personalities. Garcia was ahead of his time in developing this individualistic genre of ideologically emblematic portraits culled from printed mass-media sources.

Garcia's selection of mechanically reproduced images has consistently implied a socially committed stance. Much of his imagery from the seventies was overt. By the time he created the brilliant and densely colored pastel portrait *Mao* (1977), his position was obvious. An observation about the work, written by Garcia several years later, provides an interesting view of his politicization. "While on the faculty of San Francisco State University's Ethnic Studies Department in 1969, a Xeroxed copy of Mao's essay 'On Art and Literature' was anonymously placed in my [mail] box. I read the essay several times. Mao's penetrating analysis of the role of art as experienced in China both intimidated and encouraged me. I had never before read such an acute analysis of the socio-political responsibility of the artist to society. In addition to reading this essay, Mao's courageous role in liberating China prompted the creation of this pastel."[6] In retrospect, he noted, "both the 1940s photograph of Mao with the Soviet Union's hammer and sickle in the background and the pastel portrait of Mao, have quite a different meaning today than the earlier source photograph, especially since the Sino-Soviet split. What was wanted [to be depicted] was a Mao of controversy; what was achieved now appears quite surreal."[7]

Garcia executed the sumptuously colored monumental portrait *Frida Kahlo* in 1980. A tour de force of abstract representational design, the painting's alluring, lyrical forms are isolated in slightly blurred, color-accented contours that retain something of a hard-edge character. Its velvet textures and compressed pigments are meticulously worked and subtly modulated in broad, expansive fields of contrasting colors. The portrait's subject is almost as much Garcia's intense style and distinctive technique as it is the tragic and extraordinary Mexican communist painter and wife of Diego Rivera, Frida Kahlo, whose heavy, joined eyebrows are now joined by Garcia to the bold and beautiful shadows cast by her eyes and nose. The close-up, radically cropped image for this painting was reversed from an earlier cropped reproduction of her 1940 *Self-Portrait with Veil*, which had appeared as a paperback book cover of a Mexican biography of the artist. Garcia holds a deeply felt devotion and esteem for this woman painter; this is the second of three portraits he has done of her. The first appeared as a serigraph print in 1975, and was used for a Galeria de la Raza poster-calendar for 1976. The print is based on a color photograph on the cover of the Frida Kahlo Museum catalogue, which the artist picked up on his first trip to Mexico City in 1973. To my knowledge, it is the first work by an American or Chicano artist to render symbolic homage to Kahlo, who subsequently has experienced a widespread resurrection in the international art world. She has become especially important to feminist and Chicana/o artists, many of whom focus on her portrait image as an important artistic motif, symbolic of Mexican cultural, political, and personal strength in the face of adversity. The pastel portrait was also used as the cover to a bibliography the artist compiled on Kahlo, the first published in this country.[8]

An earlier and important example of what art critic Thomas Albright characterized as Garcia's "radical political portrait" genre, "a genre that seems uniquely his own,"[9] is the serigraph *Picasso* (1973). Created as a personal homage to the great Spanish master in the year in which he died, this posterlike serigraph is executed in deceptively simple, flat forms, with tense contours in solid blue,

ochre, dark brown, and white producing powerful, resonating contrasts. Garcia was aware of Picasso's radical political leanings, as was the whole world through the mass media. This controversy only added to the sensationalism of Picasso's public aura as exploited by the media. Garcia noted that he was paying homage "to the maestro and painter of the anti-fascist mural *Guernica*," who "to his last living and producing days exemplified the importance of the human need to openly create in order to free oneself from becoming rigid and pessimistic about the future of mankind, especially at times of world crisis."[10] The symbol of Picasso the man and what he stood for, both ideologically and artistically, was exemplified for Garcia by this familiar mass-media image.[11] Aware of its implications in the popular visual consciousness, he selected it in order to assert his own sympathies and identification with a great modern artist whom he considered not a radical political dogmatist, but a humanitarian with a social conscience, as exemplified in Picasso's pre-eminently humane and political *Guernica*, inspired by the barbarous bombing of a Basque town by German aircraft in the fascist service of Franco during the Spanish civil war.

On one level, the Picasso serigraph was executed as a statement of ideological solidarity with the recently deceased artist. On another level, it was an artistic response to the visual possibilities afforded by the tonal contrasts and irregular shapes he saw in the photograph. The striking features of Picasso's face and the potent formal qualities of the photograph—rendered even more abstract and interesting to Garcia by the unpredictable and degrading techniques of mechanical reproduction, thrice removed from the original—were the source for Garcia's masterful composition of precisely patterned shapes and evocative contours. Garcia's radical cropping of the original source adds to the dynamic tensions in his own elaborated versions of the portrait. The dark skin pigmentation of the first serigraph alluded to Garcia's symbolic association of the relatively dark Malagueñen Spaniard Picasso with people of color and with their liberation causes.

Garcia had earlier produced an homage serigraph portrait of the Mexican painter José Clemente Orozco. It was based on a reproduction of Orozco's 1942 *Self-Portrait*, which served as the frontispiece for the English edition of his autobiography. The serigraph was made for the first poster-calendar issued by the Chicano-Latino Galeria de la Raza in San Francisco's Mission District. Although drawn from on a highly expressionistic self-portrait by Orozco, it shares almost no similarity with the painting other than the familiar contour of Orozco's facial features, framed by his distinctive owl-shaped eyeglasses, and flaring nostrils. This successful work displays Garcia's propensity for radical, eccentric cropping of the original source, in this case a shoulder-length portrait, and the infusion of remarkably brilliant, arbitrary color into what was an otherwise drab reproduction.

Both the Orozco and Picasso serigraphs established the formalist authority of the artist's expressive contours and sense of color. Garcia continues to produce a constant tension between what is figuratively representational and what is calculated to be abstract design, especially in schematic shapes and contours. In his pastel paintings, figures are now heightened with brilliant areas of saturated or superimposed color activated by divided strokes of chalk and vigorous, painterly rubbings and smudges. The powerfully symbolic and evocative shape of Picasso's head and his stoic gaze were recycled a third time in Garcia's monumental pastel painting *Picasso* (1985). This profoundly moving portrait displays Garcia's recent engagement with expressive painterly figuration using vigorous textural relationships and hazy, atmospheric qualities in the pastel medium. In this

latest version, Garcia has reinfused his original reductive image of Picasso's face with a physically agitated presence. Aggressive smudges of pastel pigment are rubbed and stamped in a pattern of darkly glowing marks that vibrate and radiate around the head, enlivening what had been the stark, hard-edge contours of shadows. This haunting, spectral treatment expresses and recalls the unharnessed creative powers of this venerated modern master.

As early as 1973, Garcia began to attack the reigning empire of Western art and cultural monuments from a critical Third World perspective, using attractive quotable images of artists and celebrities engrained in the popular imagination and in the minds of the artistic elite, as points of departure. It was a logical development coming out of his training in the American pop and conceptual art milieu, which will be discussed below, but a development also directed ideologically by the artist's developing personal, political, and artistic identity.

The subject matter of American pop art was derived essentially from American commercial mass-circulation arts, including sensational newspaper and magazine photographs proclaiming American values, mythical or real. As the English art historian Michael Compton observed in his assessment of the Anglo-American pop art movement in 1970, "this subject matter carries the ambivalent feelings that both Americans and foreigners often feel for the society of the United States: the attraction of the glamour of the richest country on earth and the envy and hatred of a state mythically—if not actually—committed to the single-minded pursuit of money and powerful enough to dominate most other countries economically and militarily."[12]

In this sense, pop art was easily identified by Garcia with those aspects of American culture to which Third World peoples found themselves most instinctively hostile. By that same year, in 1970, Garcia had completed his graduate degree in printmaking at San Francisco State College, where he had been steeped in the techniques of pop art. Responding to the realization that his adherence to a growing proud notion of his Chicano heritage and identity conflicted with mainstream America both culturally and socially, he inverted this ambivalent conceptualization of pop art and its stock subject matter, turning, as Thomas Albright noted, "the images of mass advertising against themselves in devastating ways."[13]

Garcia appropriated the pictorial devices and premises of pop art and subverted them from a Chicano and Third World perspective to serve his aesthetic and ideological ends, which were very different from the cool detachment and politically disengaged "neutrality" of Anglo-American pop artists and their legacy, the contemporary post-pop "image-scavengers."[14] In the early seventies, Garcia was already working with issues, which artists such as Sherrie Levine, Thomas Lawson, and Richard Bosman began to define only in the early eighties as "image-oriented" and "ideological appropriations," that questioned modernist art and its images in a contrived post-modernist context. However, Garcia does not "appropriate" images in a calculatedly vapid response to a "culture of reproduction" or direct obtuse dialectical exercises against it. In his early posters, he often appropriated pop images in order to subvert their conventional meanings, and in his later anti-pop art paintings, he pays homage to esteemed and politically symbolic works of art or photography as calculated by his personal political and artistic ideology.

After his graduate studies in art history, which he undertook at the University of California, Berkeley, in the seventies, Garcia's symbolic quotations of great politicized artists' self-portraits were followed by strategic quotations of famous ideologically or socially charged works of art. Glossy

high-art reproductions found in expensive coffee-table art books and catalogues interested him as well. They provided fodder for interesting ideological art historical juxtapositions with social and political ramifications. More recently, these image sources have been exploited in his heroic pastels, such as *For Caravaggio and the A.L.B.* [The Abraham Lincoln Brigade] (1985), based on the famous Robert Capa photograph of a fatally wounded Spanish Loyalist soldier and a cropped fragment of the renegade baroque painter's portrait by Leoni. In this large painting the imposing field of blue sky is carefully modulated by shades of light and dark pastel tones. In contrast, Caravaggio's monumental portrait is rendered almost monochromatically in soft, pale tones and colored nuances beneath the grays, rubbed rapidly with the palm of the artist's hand and his fingertips. These gradations in turn are offset by deep velvet blacks, giving the Italian artist a fierce and defiant demeanor. Garcia began working powdered chalk pigment very deliberately and methodically at first, as in his brilliantly colored and carefully hatched portrait *Vincent* (1980). Only in the past three years has he begun to work as loosely, spontaneously, and rapidly as in the large diptych *For Caravaggio and the A.L.B.*, which set the stage for his present, most painterly works.

In *Une Enigme/A Riddle* (1984), another dialectical confrontation occurs between two very differently politicized French painters. Placed symbolically on the right is the officially legitimized, and therefore tainted, romantic rebel-artist Delacroix, who stares arrogantly at the viewer dressed in dandyish black and red attire (symbolic colors chosen by Garcia). Delacroix's allegorical Liberty celebrating the July Revolution of 1839 is quoted by Garcia and transformed into a brown-skinned symbol of Victory, whose red and black banner (it is the French tricolor in the original) is proudly saluted by a squinting Léger. Léger is dressed in a common worker's frock, also in the revolutionary colors of red and black, and wears a humble cap. Symbolic colors, especially those that allude to specific racial and political associations in the popular imagination, are important elements in Garcia's works.

From his earliest silkscreen posters and serigraphs to his latest pastel paintings, the opaque projector has been a crucial tool for Garcia's images and the development of his style. Selecting his motifs for screen prints and pastels from mechanically reproduced illustrations and second- or third-hand printed sources, he recomposes images, or parts of them, by means of the projector. Infrequently, he will use slide projections of earlier silkscreen prints or cropped fragments of those prints as sources for his larger pastel paintings. This pictorial technique has provided a certain stylistic consistency that evolved directly out of the aesthetic of his stencil prints. The stencil image and its simplified forms and contrasting colors are critical for Garcia's work, as are the chance-induced technical imperfections of certain lesser-quality reproductions in books, pamphlets, photocopies, or weather-beaten commercially printed flyers—all provide Garcia with formalist possibilities to be explored and manipulated.

Preparatory drawings for Garcia's pastel paintings are rare. He often composes his paintings directly on large sheets of paper, relying on conceptual and intuitive responses to the expressive possibilities of the projected image. The quick sketch on graph tracing paper for *La Virgen y Yo* (fig. 1) is even rarer. He later projected a photocopy of his source onto a larger sheet of paper to work out his composition, following the dynamism of the initial pencil strokes with pastel chalk over the saturated fields of golden color. With the aid of the opaque projector, he might also project a prepartory drawing combined with a collage of printed media clippings and photocopies onto a

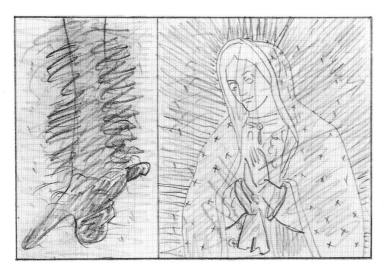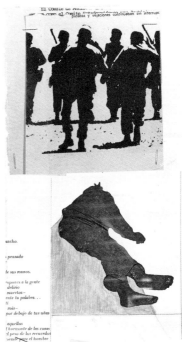

Above: Figure 1. *La Virgen y Yo* (study for pastel), 1984, graphite and color pencil on graph tracing paper, 10.2 x 15.2 cm. *Right:* Figure 2. *Mexico, Chile, Soweto…* (study for pastel) 1977, newspaper, photocopies, color pencil, and staples on mat board, 27.9 x 15.2 cm.

larger support, working out his radical and elliptical cropping with the framing edge of the paper. The *Mexico, Chile, Soweto…* preliminary study (fig. 2) is one such example. As can be seen in the final pastel painting, Garcia has exploited the high-contrast areas in the reproduced image and dramatically manipulated the pictorial space to heighten the visual and psychological impact of this media-inspired denunciation of political violence and cruelty. The clippings used for this collage were taken from a black-and-white illustration in *Alero*, a cultural magazine published by the University of San Carlos, Guatemala, and a high-contrast reproduction found in a Spanish language newspaper published in the United States. Many times the cultural locus of a found image is conceptually and symbolically important to Garcia's working method, as in this case. There is another visual sensibility behind the finished composition of *Mexico, Chile, Soweto…* (1977), and that is the filmic sensations with which we have all become familiar in the past two decades—the abrupt panning of the television news camera, filming scenes of political violence quickly or clandestinely because of imminent danger to the visual recorder. The abrupt, oblique angles of newspaper photos taken hurriedly are also recalled. Garcia also acknowledges the Franco-era paintings of Juan Genovés, with their artfully distanced and equivocal references to political violence and repression, as a source of inspiration for his own manipulations of space and form in similarly motivated works. But Garcia's forthright, heroic scale and amplification of representational subjects make his intention clear.

Another work that uses the media to reflect Garcia's ideological maturation is his sensitive portrait *J. Robert Oppenheimer* (1982). Ever since attending a lecture by Mortin Sobell in the early seventies at the YWCA located near the University of California, Berkeley, the artist has had a sympathetic interest in Oppenheimer's fate. Sobell had just been released from prison after serving

close to twenty years for espionage related to the Rosenberg case, and he discussed Oppenheimer in the lecture. A decade later, in 1982, Garcia saw the documentary *The Day After Trinity* on television. It moved him considerably. Subsequently he collected the leaflet announcing the film's screening in Berkeley, which was illustrated with a poor quality black-and-white Xerox reproduction of an early photograph of the controversial physicist. Garcia found the documentary fascinating for the moral tribulations faced by one of the fathers of the atomic bomb, and for Oppenheimer's early political sympathies that brought about his persecution by one of the more spectacular McCarthy-era witch-hunts. Garcia also read a captivating biography of the tragic early life of the scientist. He was moved to express his own sympathetic vision of Oppenheimer in a powerful portrait focused intensely on his face. Using dramatic modulations of low-key colors and shadows, Garcia exploits in this work all the qualities of line, color, and grain, and especially the deep saturation of blacks afforded by the pastel medium. The portrait is heightened by expressive, parallel hatchmarks that are offset by the piercing ice-blue clarity and stark, opaque whiteness with which he renders Oppenheimer's prophetic eyes. This work is pivotal, for in it Garcia began to experiment with rubbing the pastel pigments directly with his fingertips.

More recently, biographical sources accompanied by famous or visually distinctive photographs of writers have also served as points of departure for Garcia's politically emblematic portraits of great culture figures. One such work is Garcia's looming depiction of the late Spanish surrealist filmmaker Luis Buñuel, whose left eye has been rendered by the artist to recall the startling opening of Buñuel's early film *An Andalusian Dog*, in which the eye of a woman is horrifically sliced by a razor. The portrait *Luis Buñuel* (1983–84) reflects both the procedure of appropriation that Garcia uses and his enormous capacity for making broad artistically and historically motivated references and cross-references that are culturally and politically bound. The coloration of the portrait in itself heightens and elaborates on the visual power of the original black-and-white Man Ray photograph, which has been greatly enlarged and radically cropped by Garcia. A photograph of the young Buñuel taken by Man Ray in 1929, the year the movie was made, had caught Garcia's eye as he read an excerpt from Buñuel's autobiography in *Vanity Fair*. He decided to retaliate—having felt for so long that his own senses had been nightmarishly assaulted by the shocking sequence in the film. He also intended the painting as a gesture of homage to the filmmaker, who died in Mexico in 1983. His autobiography, which Garcia eventually read in its entirety, recounts Buñuel's life in exile from Franco's Spain, and was itself an inspiration to Garcia.

The proliferation of Orwellian literature that same portentous year of 1984, accompanied by much press coverage, including a cover story in *Time* magazine emblazoned with the caption "Big Brother's Father," stimulated Garcia to create his own seductively bold portrait of the writer entitled *My Name Is Not George Orwell* (1984). It is not coincidental that the *Time* magazine cover portrait of Orwell was also done in pastel in a very different style by one of Garcia's favorite artists, R. B. Kitaj. Garcia also had read an intriguing and inspiring biography of Orwell at the time.

Garcia's range of references is historicist and vast. His work, however, remains focused on the paradoxical anti-pop strategy of attacking the premises of pop art with his iconographical conceptualizations. From 1975, when he changed media, to the present, these ideologically charged paintings have been rendered in large, at times heroic, scale and intense colors. In addition to emblematic portraits and expressions of universalized political realities, Garcia's works are also personal reifica-

tions of elemental forces, as in the celebratory *A Sometime Self-Portrait* (1985). This pastel is executed in magnified jewellike forms of opalescent colors intermixed with transparently worked chalky pigment. Other paintings are activated with the gestural power of broad massings and rubbings of somber, raw, or brilliant colors often highlighted by primal accents left by the vigorous direct marks of the artist's fingers. One such work is the enigmatic autobiographical *La Virgen y Yo* (1984). According to Garcia, this work, among the artist's more personal, was inspired by three sources.[15] It recalls chromolithographs of the famous miraculous image of the Virgin of Guadalupe, which Garcia saw as a child in his home on the bedroom wall of his devout grandmother and in Mexican-American church-related activities. According to tradition, the Virgin of Guadalupe had appeared as a brown-skinned madonna on Tepeyac Hill on the outskirts of Mexico City to a recent Indian convert in 1531, and she subsequently became the country's most important religious and nationalistic symbol. The diving, dark figure with outstretched arms on the left-hand side of the large diptych can be read as a self-portrait of the artist, inspired by a book illustration of a popular Mexican commercial wall-painting depicting a satirical butchering scene, in which the butcher hangs upside-down on a meat hook while a bovine stands on his hind feet holding a butchering ax, joyfully laughing at the reversal of roles. Significantly, in the book, the reproduction is captioned "painting of the People."[16] This painting's creation and format reflects Garcia's interest in Mexican folk *retablo* paintings or ex-votos, the depiction of the miraculous intervention of a holy personage saving the pictured person from disaster. *La Virgen y Yo* is in essence a large and fantastical form of magical, visual prayer. The beautifully suspended, diving figure also recalls for Garcia the daring Papantla Fliers of Veracruz, the Indian *voladores* performers who hang from a high pole and drop to the ground in spiral movements from a rope.

Several of Garcia's early works illuminate the stylistic and conceptual realization of his later, more important paintings. By 1970, the young Chicano art student had become a fully trained, professional artist and had earned an advanced degree in art practice—a rare aspiration and even rarer accomplishment for a Chicano at the time. There were the usual oppressive obstacles of the "unfinished man" type that he had to contend with along the way because of his social and political ideals. An early student work, the small *Untitled* collage of 1968, demonstrates Garcia's prestrike experience as a product of the American art school free-for-all of the 1960s, which by middecade offered an undisciplined grab bag of poorly understood modernist innovations, all clichés for the taking.[17] Judging by the many products of that experience, it appears that one needed only to have enough stamina and ephemeral artistic weirdness to survive. Nevertheless, the compositional plays and manipulations of the collage reveal just how much a part the symbolism of shapes and figures, found images, and visual collages would play in Garcia's future work. The loose, floating shapes with vibrating, fuzzy, or crisp edges in Garcia's more recent large diptychs and triptychs in fact resemble large painted collages.

The *Untitled* collage is also a miniature summa of the art-school lingo of the sixties. It is infused with a pop art and neo-dada sensibility that would be transmuted by most American artists into a streamlined minimalism by the end of the decade, and which would affect even strictly figurative artists such as Garcia. From early on, Garcia was struck by the minimalist possibilities of color and condensed compacted forms, which he later elaborated, first in his sharply contoured posters, then in his looser, representational pastel paintings. The hard-edge and integrated-image quality of the

tiny, vertical stripes of color and the soft, sensual quality of dislocated sexual references were inspired by his most important artistic influences at the time, R. B. Kitaj and James Rosenquist. The collage's formalist tensions and space were similarly inspired.

The tiny collage also reveals the early sources of Garcia's heightened cropping sensibility and abstract graphic design. According to the artist, the German refugee artist John Gutmann taught him his greatest lessons in composition and design at San Francisco State. Gutmann exposed Garcia to the works of contemporary European artists such as Adami and Genoves, both users of pop-inspired pictorial devices. Garcia also admired the spatial concerns of Kitaj and the early Magritte. Dislocated figurative design was crucial in Garcia's early silkscreen prints, and Magritte's stark treatment of isolated, incongruous objects in pristine space appealed to him. The artist also recalls that his own fragmentation technique was stimulated by the charged sense of drama he had seen in the collage-derived paintings of Kitaj at an exhibition in Berkeley during this time. He felt that "Kitaj's work had a certain kind of urgency to it, with which I identified. I felt myself fragmented." This revealing observation tells us much about his recurring preoccupation with the notion of humans as "unfinished"—socially, psychologically, and even artistically—which he would later elaborate in his conceptual works referring to the oppressed "unfinished" man and woman in American and Third World society. He continues to express social and political alienation plastically as a visual fragmentation of figures, shapes, and forms with tension-bound formal dislocations.

This melding of an artistic and ideological conception of fragmentation contributed to the stylistic development and evolution of his work as he came to realize it from that critical year of 1968 to the present. It is a major theme to be considered in assessing this early and midcareer retrospective of Garcia's work. The social fragmentation that he perceived and articulated visually in his early development, and later expressed in blown-up, fragmented images of human alienation and political resistence, is possibly the most important recurring theme of his work.

Some important facts about Garcia's life also have considerable bearing on an understanding of his work and the development of his art. Rupert Garcia was born in French Camp, California, a small agricultural town in the San Joaquin Valley, in 1941. He was raised in nearby Stockton by his mother, a meat-plant worker in those years, and by his grandmother, Maria Guadalupe Atilano. While in high school he "ran" with what he remembers as a microcosm of "the Third World and poor whites—a group of Orientals, Negroes, Oakies, and Mexicans," as they were then called.

Garcia's artistic talents developed by copying cartoons and figures in comic books and magazines, as well as mimicking images seen on the television screen. His remarks regarding his early love of drawing from magazines and comic books are revealing: "I've been involved with photographs since the fifties, using photography and reproductions as an important frame of reference for making a picture. I didn't have any schooling that told me not to do that, that it was cheating." He received along with the rest of his American generation an artifical celluloid—now video—world view through the phenomenon of image glut. His quotations from mass-media imagery evolved out of a perfectly normal preoccupation of the class-bound masses, of which he was a part, and their captivation by WASP-ish, media-created fantasy worlds.

Garcia's mother owned a large collection of movie magazines, and he often used the photographic images of stars and characters in them as source images for drawings. In fact, it was from

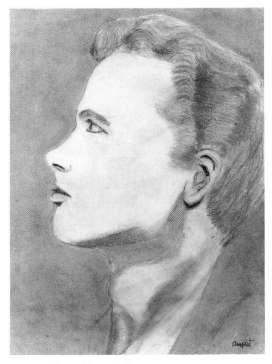

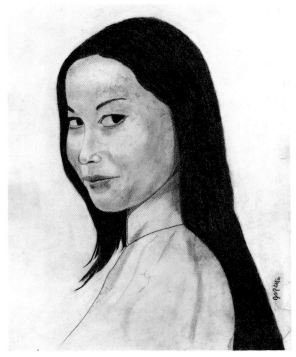

Figure 3. *James Dean*, 1959,
pastel and graphite on paper,
29.5 x 22.2 cm.

Figure 4. *Nancy Kwan*,
1961, graphite on paper,
40 x 28.2 cm.

one of his mother's pulp movie magazines that Garcia drew with pastel chalk the popular actor James Dean (fig. 3) in 1959, his first authentically pop image, clearly *avant la lettre* for what it represented as an art object. Even his early predilection for the medium of pastel is ironically foreshadowing. The drawing is remarkably faithful in coloration to poor-quality, mass-media publications of the fifties. An alluring pencil drawing of the actress Nancy Kwan (fig. 4), interesting for his choice of subject matter, is also in the artist's collection. Garcia's appropriation of images from the Hollywood dream factory as a youth and art student paralleled in a curious way the experience and original inventions of the Anglo-American pop artists and their precursors, Rauschenberg and Johns, who reacted against the modernist aesthetic hedonism and nihilism of abstract expressionism. In his own unique way, Garcia reacted against pop art. He eventually evolved into an authentically "popular" (as in "artist of the people"), anti-pop artist.

Garcia's legitimization in a Chicano artistic heritage was provided mostly by his grandmothers Guadalupe Atilano and Pascuala Garcia. Guadalupe was responsible for instilling in him from a very early age a keen interest in working with objects and color and transforming disparate things into art, such as making wooden figures from clothespins. Garcia vividly remembers that she amazed him by making entire figurine ensembles—animals and people—out of twisted tissue paper. The artist also recalls the visual excitement of seeing the colorful costumes designed by his grandmother Pascuala for the local ballet folklorico.

His grandmother Guadalupe's religiosity and orthodox Mexican values became an especially compelling motivation for *La Virgen y Yo*. According to Garcia, a very strong Mexican cultural ambiance existed in Stockton during his youth, and many contacts with Mexico occurred directly through family ties and in the enclaves of undocumented workers, who were then simply identified, as he was, as *mexicanos*. Consequently, he never questioned his cultural identity as a "Mexican" living and growing up in America. For economic reasons familiar to many of his generation and social origin, he was unable to visit Mexico, even as a tourist, until he was much older, in 1973. On his return from this trip to study the murals in the ancient city of Teotihuacan, Garcia was moved to execute the serigraph entitled *Maguey de la Vida* (1973). It is based on the famous Edward Weston photograph of the distinctive agave plant, reproduced in Anita Brenner's *Idols Behind Altars*. But, as a youngster, he had no real interest in Mexico, an attitude fostered by the American educational system of the fifties and early sixties, which frowned upon anything Mexican. Teachers and administrators attempted to Americanize children of Mexican descent, even those whose families had been on the land generations ago, when California was part of Mexico, families whose cultural and linguistic rights continue to be protected to this day by the 1848 Treaty of Guadalupe Hidalgo. Garcia remembers that he "didn't feel there was any reason to visit Mexico," until he realized "that Chicanos are not Mexicans," a distinction that was not apparent to him until his active participation in the Chicano and La Raza social movements. By then, during the late sixties, the term "Chicano" had been adopted by the formerly "Mexican-American" student movement as an ideological label strongly affirming solidarity with the lower working class of Americans of Mexican descent, mostly agricultural workers. The label was proclaimed by the increasingly militant young students of Mexican descent coming to terms with the American racial and cultural oppression and discrimination that had been experienced stoically by their parents, and now by themselves, in the socially dysfunctional institutions of American society. Although today he is wary of being categorized as a "Chicano" artist, in a restrictive sense, "by people not knowing the specifics and complexities of the term" and the authentically pluralistic character of Chicano art, Garcia nevertheless maintains such an identity privately and among his peers out of solidarity with the Chicano art movement, of which he has been a leading figure.

After attending high school and pursuing an art degree in junior college, Garcia migrated to San Francisco to try to make it as an artist. A disappointing series of odd jobs followed, culminating with steady employment as a dishwasher. He returned to Stockton in disgust, only to find himself at the recruitment station, desperate for "something to do" with his life and seeking some sort of economic security. After several uneventful years in the Air Force at remote bases in this country, Garcia was sent to Thailand and neighboring areas. He experienced there the horror of death dropped anonymously from the sky on people of color by the machines he was assigned to guard. He was intimately familiar by then with the motives and inequalities of the society that made those machines, but had not yet seen the possible alternatives to that society.

Garcia returned to the U.S. in 1966 to work in a can factory in Stockton. His artwork had been eclipsed by his darker human experiences overseas and the vacillations of life. With the aid of the G.I. Bill he decided to enter art school again, this time at San Francisco State College, where he studied under the photo-realists Robert Bechtle and Richard McClean, but most important, John Gutmann.

He earned a bachelor's degree in painting in 1968, then an advanced degree in printmaking in 1970. His master's thesis, written in 1969, was entitled, significantly, "Media Supplement." Primarily about "information," it explained what he had come to see as constants in his work: his "visual sensibility and his resentment of the oppressor."[18] It was both an exposition of Garcia's understanding of pop art as a movement and its techniques and an attack on its premises as well.

The thesis is a clear confrontation with the inherent apathetical problems of aesthetics and ideology in American pop art at the time. Garcia voices his concerns about the design and delivery of information in the mass media, especially in America, and its use in the pop movement. In it he sought to expose the media's conspiracy of boredom and banality that bombarded the public with clean-cut images or degrading perjorative stereotypes such as the "Frito Bandido" and the grinning, black cook serving up Cream of Wheat (the latter the subject of an early hilariously subversive "answer" poster by Garcia), desensitizing and dehumanizing the American consumer, including the consumer of the daily news, from reality. Garcia also exposed Anglo-American pop art's utter complacency and complicity with this attitude. This emphatic statement from his thesis affirms Garcia's motivation for using appropriated images in his posters and later pastels.

> My art is committed to the paradox that in using mass-media I am using a source which I despise and with which I am at war. In using the images of mass-media I am taking an art form whose motives are debased, exploitative, and indifferent to human welfare, and setting it into a totally new moral context. I am, so to speak, reversing the process by which mass-media betray the masses, and betraying the images of mass-media to moral purposes for which they were not designed; the art of social protest.[19]

In his work, Garcia sought to betray or more clearly transform the images of the mass media, particularly representations of political events, incidents, and culture heroes. He wanted to manipulate objective reality as seen by media-makers and media-watchers, transforming images of Che Guevara, a black Everyman, a female stereotype, a political murder, etc., into blatant images that clamor for redress and justice and recognition of all peoples' humanity. Without a doubt, however, as he freely acknowledges, Garcia was very much influenced by the major artists of the sixties. In the late sixties, Garcia was drawing naturalistically from reproductions, and had not yet recognized the tremendous creative possibilities of the flat two-dimensionality of the reproductive-image source. When he began to design political posters in the silkscreen technique, he wanted the message to be immediately identified, and so used bold images and words, eye-catching colors, and clear spatial definitions.

In 1968 he became aware of the significance of the artist's role as social activist when he began to produce posters in the poster workshop of the San Francisco State strike. Garcia began to collect as source material for his picture morgue the detritus of political protests, charity functions, meetings and lectures. These included announcements supporting Third World liberation struggles being fought on the American propaganda homefront of the early seventies that were posted on the kiosks, storefront windows, and buildings throughout the neighborhoods that were Garcia's haunts. For the next seven years, Garcia devoted himself entirely to making cultural and political protest posters, such as the 1968 portrait of Che Guevara headlined by an emphatic "Right On!," one of the earliest posters done for the student strike bail fund and among the earliest posters made in this country depicting what would soon become the ubiquitous face of Che. By then Garcia had joined the student-faculty poster group and contributed several posters to the cause. During this

time, he became a part of the emerging Chicano-Latino artistic movement in the Bay Area, contributing posters to the Galeria de la Raza and their activities, of which he was a founding member in 1970. He continued his artistic education, working towards a master of arts degree because he wanted to "teach art." He also freelanced as a writer and graphic artist for the Latino bilingual publications *La Prensa* and *El Tecolote* in San Francisco, where he honed his talents working with media reproductive techniques and images. Around the same time, the artist designed covers and contributed drawings to the New Left publication *Leviathan*. He also designed book covers for poet friends, created graphic and animation art for television and film, and worked as an art editor for a local magazine and a book of Third World writers. A glance at the bibliography of this catalogue will indicate Garcia's prolific production as a writer, especially on the history of Chicano-Latino murals.

As a result of the 1968 strike, Garcia had turned his back on painting, convinced that making unique objects for an artistic consumer society was then irrelevant to his own existence. He began to "redefine his relationship to making art." Even technically and stylistically, while working in the silkscreen medium, he began to focus and define his virtuosity with the discrete fragmentation of figures, culling photographic reproductions for dramatic shapes and interesting tonal properties of pure colors and black. Garcia's newly learned silkscreen technique served his need for a spontaneous, quick direct image and form and negated all his earlier experiences with modulating colors and painterliness. He "was swept away" by the impact of direct shapes and the vibrancy of color he could achieve with the silkscreen technique. As he wrote in a 1975 issue of *Toward Revolutionary Art*:

> During the process of learning silkscreen, I became aware of the inherent visual and tactile qualities of this medium. The ability to achieve bright, bold and flat shapes of unmodulated color seemed to be what I was after [in 1968] in my earlier paintings, but was having difficulty accomplishing. I slowly began to understand the visual properties of the ink. Its colors could be used in an aggressive way. The matte finish of the ink absorbed the light and therefore cut down the distortion factor often caused by light reflecting from a picture with a glossy finish. I want the viewer to be able to see my pictures with as little outside interference as possible. The capacity to produce multiples of a given visual idea attracted me to silkscreen printing. The democratic idea behind making multiples also made sense to me. But, of course, what one says is as important. You can use a democratic medium (like television, for example) and deliver a fascist message. [20]

At the same time, Garcia was becoming increasingly politicized and sympathetic to Third World political and civil rights causes. He contributed countless posters and designs for various political causes throughout the country in the next decade, supporting the San Francisco strike, the efforts of Amnesty International, the struggle for Native American Indian rights, demonstrations against apartheid in South Africa, the Black Panther Party, the Farm Workers Union, Los Siete (a San Francisco Mission District group of Latino youths accused of killing a policeman), and such supporters of the Black Panthers as Angela Davis. About the 1971 Angela Davis poster entitled *Libertad para los Prisoneros Politicas!* [sic], Garcia later wrote in 1977:

> She was in prison at the time on trumped-up charges connecting her to an alleged conspiracy … to free the Soledad Brothers …. It was clearly a set-up to discredit her and get her off the street …. Being a Chicano, and developing an understanding of the common struggle of Third World and other oppressed peoples, I supported her.

20

One way of showing support for Angela's universal statement of human rights and freedom was for me to respond visually . . . with a symbol that would represent Angela Davis and her beliefs.

I wanted to use an image that would immediately capture the eyes of the passer-by. To do this, I chose a large black shape and a smaller sienna shape to depict hair, shadow and skin texture; peacock blue color was selected for the text. All of the shapes and colors were bold, flat and aggressive; the viewer couldn't help but be "grabbed" into a visual dialogue.

With regards to the text, I used Spanish to express international solidarity between Black and Raza peoples, and the solidarity with our struggling comrades in Latin America. At the time, I recall thinking especially of the Cubans and their struggles.[21]

This passionately declamatory silkscreen poster was based on a photograph of the black activist that Garcia found in a 1970 issue of the New York publication *The Liberated Guardian*. The poster was printed for the National United Committee to Free Angela Davis and All Political Prisoners, while Davis was incarcerated accused of conspiracy. The poster successfully focused attention on her unjust imprisonment, from which she was ultimately freed through judicial vindication.

The 1971 silkscreen *Attica Is Fascismo* comments on the deadly overreaction of the state to the prison riot in Attica, New York. A blow-by-blow broadcast description of the riot with sound effects inspired the artist, and the close-up framing of the scenes of violence on the evening news provided formal ideas. Garcia had by now discovered the graphic art of the Mexican printmaker José Guadalupe Posada (1852–1913), whose pre-eminent motif was the skull-skeleton caricature, the *calavera*, and in Garcia's print the *calavera* becomes a chillingly direct and forthright representation of the fate of many of the Attica prisoners, victims of fascist tactics. The poster was a contribution to the Prisoner's Union, then headquartered in San Francisco. By assigning Spanish titles, and in some cases *pochismos* (idiomatic Mexican-American Spanish expressions), to some of his posters Garcia proclaimed a Chicano solidarity with the subject of the poster. Garcia's electrifying treatment of the *calavera* motif reappears in phosphorescent colors in his later painting *Fenixes* (1984), where it doubles as a frightening image of a man aflame, and in his *Calavera y Diablo* (1985).

By the early seventies, Garcia was more interested in the issues a portrait image represented than in the portrait per se. The ideology expressed by the image was a statement of the artist's position. By appropriating the stock images of pop art as well as its pictorial devices and methods, and modifying it with his own stated ideological concerns, Garcia was creating an inverted art of cultural resistance—resistance against Anglo-American cultural imperialism, which is one of the principal definitions of Chicano art as interpreted by this author.

As a Chicano artist, Garcia's most significant and symbolic early work is his portrait of the Chicano journalist Ruben Salazar. Salazar had been mercilessly killed while sitting in an East Los Angeles bar shortly after covering for television the first Chicano anti–Vietnam War demonstration in August 1970. It was a protest against the disproportionate numbers of Chicanos being drafted and killed in combat in Vietnam, and Garcia had contributed his emotionally charged poster of an outcrying Vietnamese woman's face, entitled *Fuera de Indochina*, to the organizers of the rally for distribution there. A former writer for the *Los Angeles Times*, Salazar was, at the time of his death, the news director for a local Spanish-language television station. Unprovoked, and acting on a "tip," a Los Angeles County deputy fired a tear-gas projectile randomly into the bar, fatally wounding Salazar in the head.

The Salazar poster was designed from a photograph of the journalist taken from one of the

Chicano publications covering the tragic event. It announced the *Homage to Ruben Salazar* exhibition that was organized shortly thereafter by the Galeria de la Raza. Garcia also created a painting to serve as the centerpiece of the exhibition. It had been two years since he had done a painting, and he only conceded to paint this work because of the significance of the occasion. He decided to go from the abstract patterns in the silkscreen poster to the painting, using the opaque projector.

The painting is pivotal in Garcia's development, both for the transfer of his silkscreen aesthetic to a different medium and for its political subject matter. Garcia recalled that he tried to paint the color fields as flat and as unmodulated as possible. He didn't silkscreen the painting, as Warhol was then doing, because he "just didn't want to contend with" the notion that he was simply copying Warhol. Nevertheless *Ruben Salazar* (1970) is tremendously important for plotting the direction Garcia's work was to take toward rendering his concerns with bold images derived from the silkscreen idiom and aesthetic. These dramatic portraits of political figures of Third World liberation movements, blown-up and rendered in the lush medium of powdered color, could be spontaneously and emotionally created by the hand of the artist, without an intervening printing technique.

The subject of the slain Salazar is among the most symbolic and iconic images of the Chicano movement of the early seventies. And, Garcia considers his rendition of the journalist an example of Chicano art's true pluralism: "it's universal because we [Chicanos] are part of the human family, so whatever we make as Chicanos in the way of art, [reflects] that we're talking about ourselves as part of the world under a collective, not individualistic or nationalistic, program." This work, done many years before the New York art-market craze for grafitti-oriented art, was intended to be read from a distance, "like a *placa*" (grafitti inscription).

Garcia continued poster art in the service of social change and participated in the heroic years of the Chicano protest art movement between 1968 and 1975. In 1975, however, something very critical happened in Garcia's personal and artistic life. He realized that he was following unrealistic routes that he had naively outlined for himself in his enthusiasm for social movement with a capital M, and routes dictated by faddish American art currents—no matter how much he denied the latter's impact on his development. He began to feel that his expectations for immediate significant change in this country's social attitudes and behavior had been too romantic.

Following the 1968 strike, he had been called upon to develop and teach a course on the history of Mexican art for the newly instituted La Raza studies at San Francisco State, and had become deeply interested in the history of art, especially the art of Latin America and Mexico. After an ill-fated encounter with the less demanding curriculum of art education, he decided to enter the graduate art history program at U. C. Berkeley in 1975, but became disillusioned by the program requirements, which seemed unrelated to his experience as a Chicano-Latino artist. He dropped out, but returned in 1979 to write a thesis on Chicano murals in California and earn a master of arts degree in art history. In the process his approach to his paintings became extremely historicist and he researched the history of the pastel medium carefully. He had previously researched the brilliantly colored yarn paintings made by the Huichol Indians of Mexico, their sacred *naerika* paintings.

Garcia's *The Bicentennial Art Poster* (1975) was among the last the artist executed singlehandedly and is one of his best-known works. He created it in response to the rash of decorative fine-art

Bicentennial posters that appeared in store windows around San Francisco in 1975. According to the artist, the poster addresses the issue of violence in this country directed against people of color, "particularly the native American, who had to be almost extinguished in order for this country to celebrate its 200th anniversary." The direct source for the image was a leaflet reproducing an illustration of a dead man, a victim of repression in Argentina. Newspaper photographs and television reports of civil rights disturbances and anti-war rallies that resulted in bloodshed, the camera zooming in on dead or wounded people, also stimulated the artist's vision.

Shortly after executing this poster, Garcia became disinterested in the production aspects of the silkscreen technique, and in 1975, after seven years of working exclusively in printmaking, he stopped producing posters himself. He gave away all of his materials, but continued to design posters relegating their production to others. His 1973 serigraph *Picasso* proved to be an important stimulus for his change in medium from silkscreen to pastel. A progressive proof of the serigraph was lying around his studio, and in a moment of frustration and inspiration, Garcia experimented with the application of divided strokes of pastel colors on the partially printed surface in an attempt to produce a more energized, visually active work. He also experimented with a more opaque application of pastel and a deliberate schematic patterning on a progressive proof of a serigraph portrait of Orozco. The paper surface and its absorption and the color in the pastel medium were his primary experimental concerns. He worked with the pastel chalk on the tooth of the silkscreen surface, and produced further variation by applying poster paint to the surface, achieving intriguing textural and tonal possibilities. His first major work to combine pastel and poster paint was his portrait *Inez Garcia* (1975–77). The image and subject were derived from a front-page photograph in a local San Francisco newspaper covering the sensational story of this Latina who had defended herself against a violent rape and had been accused of murder.

Major pieces that followed her portrait and that of Lucio Cabañas between 1975 and 1979 were the moving and starkly beautiful but tragic *Mexico, Chile, Soweto...* (1977) and *El Grito de Rebelde* (1978). The latter was the first major pastel painting for which the artist appropriated an image from one of his own earlier serigraphs. The silkscreen print dating from 1975 was itself based on a reproduction of a news photo in a brochure denouncing the brutal killings and political repression by the Shah of Iran. The carefully directed, vertical hatchmarks in the painting and the stark, flat shapes of symbolically charged red, white, and blue colors (of the American flag?), offset by an oppressive field of velvet black, culminate in the figure's gaping mouth rending an excruciating scream of bared white teeth. It is one of the most powerfully direct and aesthetically successful renditions of political violence and protest in Garcia's oeuvre.

Another of Garcia's masterworks is the majestic but shocking *Assassination of a Striking Mexican Worker* (1979), executed in the true tradition of the Mexican ethos and attitude toward death as rebirth. Garcia once stated that the work "...was a conscious choice to do the worker, not only to breathe life into his death, but also his cause."[22] This profoundly moving image is based on the famous photograph *Obrero en Huelga Asesinado* (*Murdered Striking Worker*) (1934) by Manuel Alvarez Bravo. In 1978, Garcia was invited to participate in a work-in-progress experiment sponsored by the Fine Arts Museums of San Francisco Downtown Center. The theme of the project was "The Worker." Garcia seized the opportunity to make a picture of a murdered worker based on the haunting photograph.

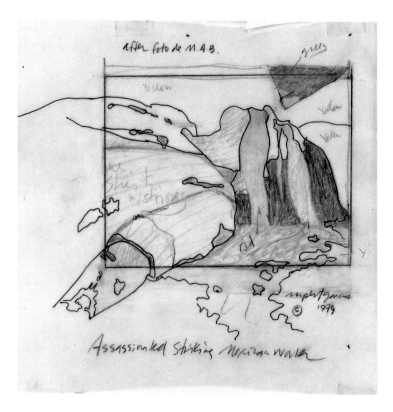

Figure 5. *Assassinated Striking Mexican Worker* (study for pastel, after Manuel Alvarez Bravo), 1979, graphite and felt-tip pen on tracing paper, 15.2 x 15.2 cm.

This masterpiece of style, form, and content is eerie in its transformation of a death mask brought back to life by brilliant screeching color. The body of the brutally murdered youth, accentuated by the vitality of its blazing, saturated reds and yellows, expresses anything but resignation in the face of such a violent end. The work is a frank quotation in homage to the formidable power of Alvarez Bravo's creativity, as well as a political statement of sympathy that becomes a humanitarian gesture of universal protest through art. Garcia insists on further identifying the figure in the title by adding the word "Mexican" to establish its geopolitical context. As a quotation, or homage, Garcia's *Assassination* is a work that does not elaborate on the original, but which further vitalizes it as a disquieting image of a protest against a tragic, politically inspired death. The preparatory drawing for this work (fig. 5) illustrates the most significant aspect of Garcia's technique in working from reproduction sources, which is the careful selection of richly saturated color contrasts, since invariably his sources, as here, are in black and white in the original, and his calculated schematic patterning and abstractions of two-dimensional forms are based on realistic photographic images.

When he began his pastel paintings in 1975, Garcia first worked very deliberately, hatching carefully with variations of divisionistic strokes of colored chalk. It has only been in the past two years, in works such as *La Virgen y Yo* and *Blue Man Fleeing Gun* (1984), for example, that he has begun to work rapidly and spontaneously, forcefully applying and rubbing in expressionistic nuances of color and agitated forms. In the large, eccentrically shaped diptych *Nose to Nose* (1985), in which the ominous dark silhouette of a U-2 plane viewed from below comes nose to nose with the

oddly shaped head of a man (derived from a carved Mexican folk-art mask), Garcia has exploded the divisionistic strokes into staccato overlays of confettilike pastel hues, creating a bizarre fiesta of pastel-colored tracer bullets randomly shot throughout the picture space and, by extension, geopolitical space.

Garcia's *Bicentennial Art Poster* of 1975, with its flat interlocking shapes so simplified that they verge on abstraction, was the appropriated source for his later pastel diptych *Prometheus Under Fire* (1984). The unforgettable central image of a supine dead man with three gaping bullet wounds in his chest appears in a dramatically foreshortened close-up from of an oblique, worm's-eye view on the left side of the diptych. In slightly elaborated form and further monumentalized in scale, the scene is rendered in vaporous strokes of pastel gradations. The fallen man appears this time with his contours blurred in hazy vibrations and crepuscular colors that evoke the distant tree line of a Southeast Asian or Central American tropical rain forest as seen from a low-flying helicopter. On the right side of this moving diptych, the wounded man-landscape's image is set off by the purplish silhouette of a sinister-shaped Cobra gun ship. The helicopter spews flaming red-orange gunfire against the backdrop of an intensely burning, saffron-colored sky, evoking visions of a napalm conflagration or waving fields of bright yellow elephant grass in the scorching tropical heat.

Garcia's monumental pastel paintings are radically cropped and their images are focused on a close-up, enlarged format of disturbing political and social realities for expressive effects. Their subjects, however, are universalized and sublimated by his command of brilliant, rich colors that sometime burst into flaming color contrasts, as in *Assassination of a Striking Mexican Workers* (1979), or *Carnival of War* (1985), which refers to any and all wars. His paintings are also personal reifications of elemental forces as in his celebratory *A Sometime Self-Portrait*, and his *Inside-Outside* (1985). The latter is an intimate, sentimental landscape and recollection of his first "real" vacation with his wife in the Canadian Rocky Mountains. It is based conceptually not on the landscape itself, but on remembered feelings about the benign, romantic setting combined with a rebounding flashback of his war experience in the Indochinese jungle.

In some of Garcia's later work, both impulses described above are combined. In his paean to a victim of the Guatemalan National Guard, *The Horse in Man* (1985), a man's head is dislocated by a garishly colored and surrealistically inspired wooden horse, a Mexican folk object. Both the horse and elements of the relational and intentionally incongruous composition are drawn from an early 1928 black-and-white photograph of a carousel horse, frozen in time by Manuel Alvarez Bravo. The photograph was taken from a treasured exhibition catalogue given by Alvarez Bravo to Garcia upon their meeting in San Francisco several years ago. The anonymous man's photograph came from a Guatemalan newspaper.

The pastel painting *Inside-Outside* (1985) completes this retrospective survey. The work is enigmatic, its autobiographical sources—private, sentimental, and internalized elements of the artist's life—expressed visually in ambiguous shadows cast abstractly by animate, natural forms. According to the artist, "it's about Indochina, a private vacation with my wife in the Canadian Rockies, it's complicated, that's all."

It is a landscape with a huddled figure inside a primitively constructed shelter that lies in the shadow of a large looming mountain. Nature is amply revealed in the rich, saturated colors of a sunset or sunrise sky that hover around the large mountain, itself interpenetrated by the eerie light

inside the structure. Somber tones of rich velvet blacks and blue greens evoke cold shadows deeply cast by the shapes of mountain snow and glacial ice. The painting is self-consciously composed in its formal and conceptual qualities to appeal and respond to the "outside" of both the artist's intractable nature as "culture watcher," in tune with where he has been in terms of artistic precedence and invention with appropriated images (here, a Kodachrome tourist picture from a souvenir brochure served as the source), and his own equivocal relationship to the confused state and media-hyped reality of American art in the 1980s.

Garcia's later work is heading toward a certain iconographical ambiguity that appears to be motivated by a more personal, intimate, and reflective vision of life, art, politics, and contemporary history in our media-dominated culture. His works are becoming increasingly sumptuous in form and color, producing a heightened spirituality. References to his ideological and historical sources are becoming increasingly oblique. But these sources can be found if one looks closely and contemplates the images in the context of contemporary global politics. It is as though the seemingly inherent contradictions between elitist fine art and popular political art from a Third World perspective (which in reality is a universal, humanitarian perspective that supports self-determination and freedom from oppression for all), have been turned gradually from the outside to the inside as reflected in the artist's work and development. Garcia's engagement with social, ideological, and political problems—concerns for the "unfinished man"—is still evident, but in the restless experimentation of his recent work has been raised again strategically to the level of "high" art. Garcia is now seeking to answer his own questions about human "unfinishedness" and wholeness in art alone, through the difficult and challenging medium of pure pastel painting. But, through his inventive forms and colors, he still seeks to move the viewer to consider important ideological and social questions.

"For," as art critic Robert Hughes ironically states about exclusively artistic concerns, "the ultimate business of painting is not to pretend things are whole when they are not, but to create a sense of wholeness which can be seen in opposition to the world's chaos; only by setting this dialectic in full view can painting rise above the complacency of 'ordered' stereotypes and the meaningless bulk of the familiar."[23] The same notion might be entertained about Garcia's paintings as they refer in a representational and original way to the human image and the contemporary human condition.

The thrust of Garcia's development as an artist has been art, politics, and art, in that order. As Garcia stated in a recent interview:

> Politics used to be my driving force. It isn't an overriding concern any more. Now it's what I think of as the world personalized. The technology of the picture has become important. Now many political works seem trying—embarrassing to one's eyes. It is very difficult to make it work. But, I like to walk that fine line.[24]

Notes

1. For an authoritative account of the strike, see William Barlow and Peter Shapiro, *An End to Silence: The San Francisco State College Student Movement in the '60s*, New York: The Bobbs-Merrill Co., 1971.

2. It is not my intention in this essay to discuss in great detail the large pastel paintings, diptychs, and triptychs, of the last two years that comprise roughly one-third of this exhibition and which were recently exhibited in San Francisco's Harcourts Gallery last year. Those have been admirably analyzed and described by Peter Selz in the catalogue for that exhibition. See *Rupert Garcia*, San Francisco, Harcourts Gallery, September 6–28, 1985. Text by Peter Selz.

3. Garcia's pastel works are characterized as "paintings," and not drawings, because drawings are essentially linear in character, limited in color, and usually modest in size, whereas Garcia's large pastel paintings are almost exclusively concerned with vibrant polychromatic, textural, and painterly possibilities.

4. Unless otherwise indicated, all the statements by Rupert Garcia quoted in this essay are from personal interviews with the artist conducted by the author in January 1986, in Oakland, California. The essay relies heavily on these recorded interviews in which Garcia related much biographical information and freely discussed his art, working method, and political views.

5. Jerome Tarshis, San Francisco: Rupert Garcia at Harcourts, *Art in America*, February 1986, p. 133.

6. Unpublished statement written by Garcia for a proposed book in 1980.

7. Ibid.

8. Rupert Garcia, *Frida Kahlo: A Bibliography and Biographical Introduction*, Berkeley: Chicano Studies Library Publications Unit, University of California, Berkeley, 1983.

9. Thomas Albright, "Rupert Garcia: Radical Political Portraitist," *San Francisco Chronicle*, April 28, 1983, p. 60.

10. See note 6.

11. The photographic source from which the artist made a preliminary drawing for the serigraph poster was taken from a now-lost mechanically reproduced source in 1973.

12. *Pop Art*, London: Hamlyn, 1970, p. 30.

13. Thomas Albright, "Oakland Museum: A Wide Range of Latin Art," *San Francisco Chronicle*, September 12, 1970, p. 33.

14. For a history of this phenomenon, see Benjamin H.D. Buchloh, "Allegorical Procedures: Appropriation and Montage in Contemporary Art," *Artforum*, September 1982, pp. 43–56. See also the catalogue for the exhibition *Image Scavengers: Painting*. Philadelphia, Institute of Contemporary Art, University of Pennsylvania, December 8, 1982–January 30, 1983. Text by Janet Kardon.

15. Correspondence with the author. See also Selz's discussion of this work in the previously cited catalogue.

16. The reproduction is from Emily Edwards's *Painted Walls of Mexico*, Austin: The University of Texas Press, 1969, p. 141.

17. See the penetrating analysis by Robert Hughes, "Careerism and Hype Amidst the Image Haze," *Time*, June 17, 1985, pp. 78–83.

18. Rupert Garcia, "Media Supplement, 1969–1970," Unpublished master's thesis, Department of Art, San Francisco State College, 1970, p. 1.

19. Ibid., p. 11.

20. Statement published in *TRA (Toward Revolutionary Art)*, no. 6 (vol. 2, no. 2), 1975, p. 20.

21. "Chicano Poster Art: An Interview with Rupert Garcia," *The Fifth Sun: Contemporary/Traditional Chicano & Latino Art*, Berkeley: University Art Museum, University of California, Berkeley. Exhibition catalogue. October 12–November 20, 1977, pp. 29–30.

22. Quoted in R. J. Harris, "Garcia's Portraits Explode Off the Walls," *The Portrero Hill View* (San Francisco), February 1981, p. 5.

23. Robert Hughes, *The Shock of the New*, New York: Alfred A. Knopf, 1981, p. 406.

24. Quoted in Bob Marvel, "Rupert Garcia, Personalized Politics," *La Voz* (Seattle), June–July 1985, p. 26.

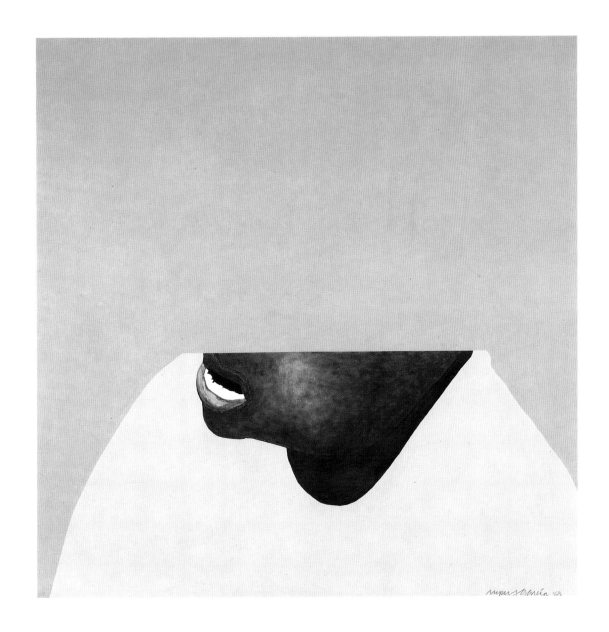

1. *Unfinished Man*, 1968

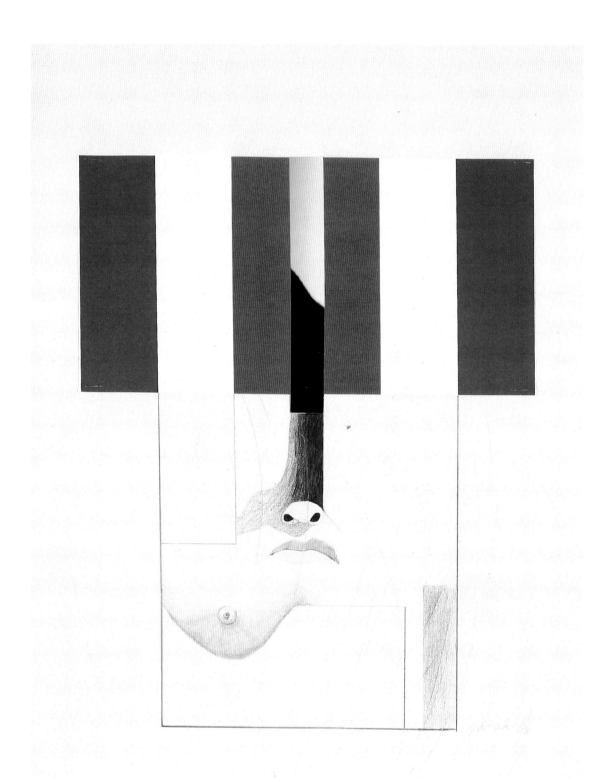

2. *Untitled*, 1968

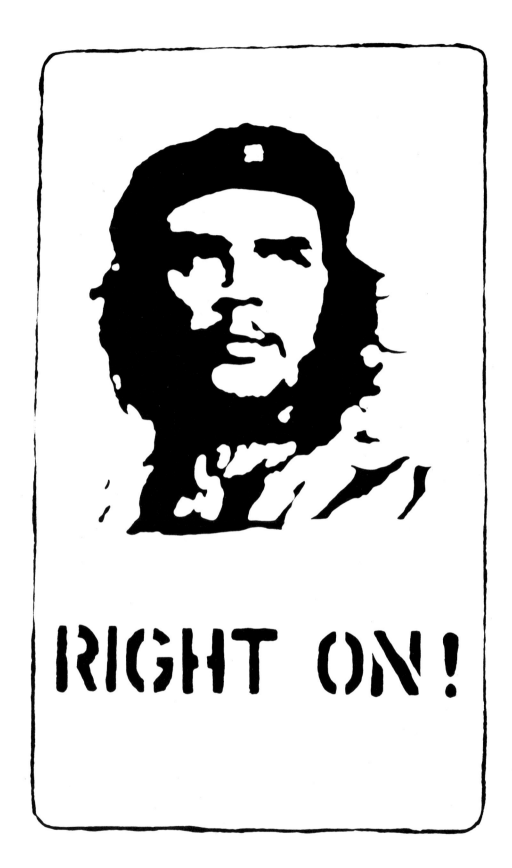

3. *Right On*, 1968

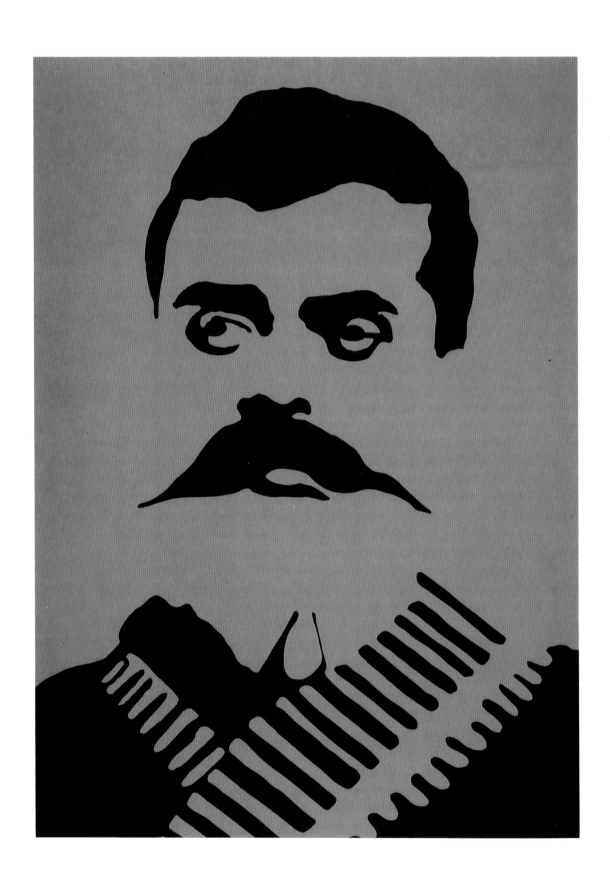

4. *Zapata,* 1969

5. *Down with the Whiteness*, 1969

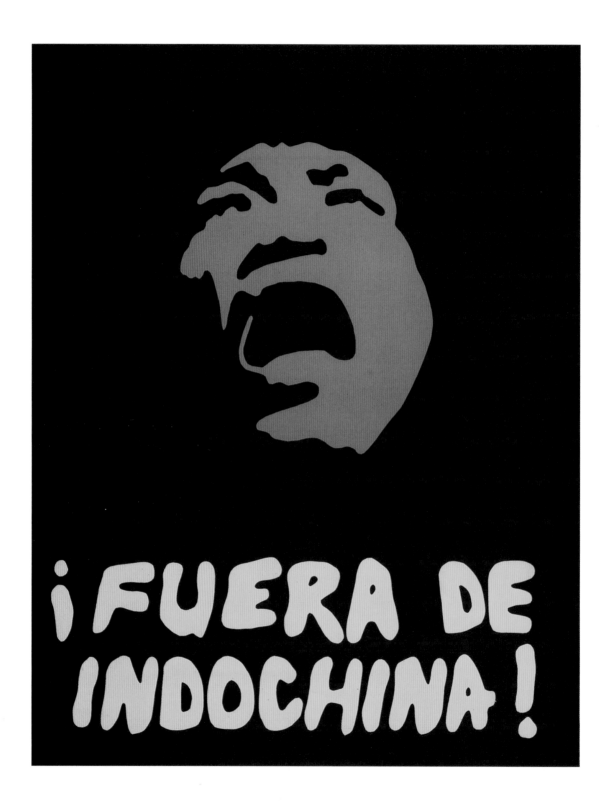

6. *Fuera de Indochina*, 1970

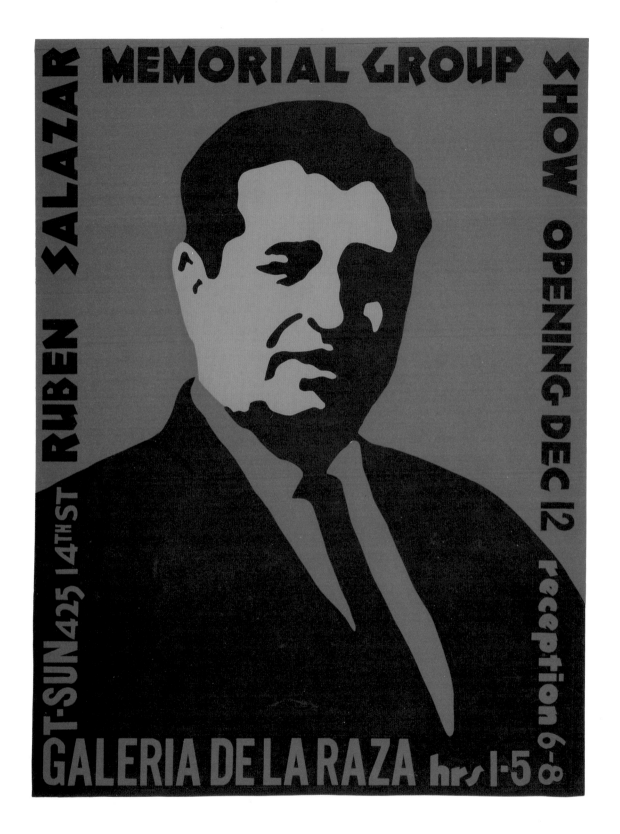

7. *Ruben Salazar Memorial Group Show*, 1970

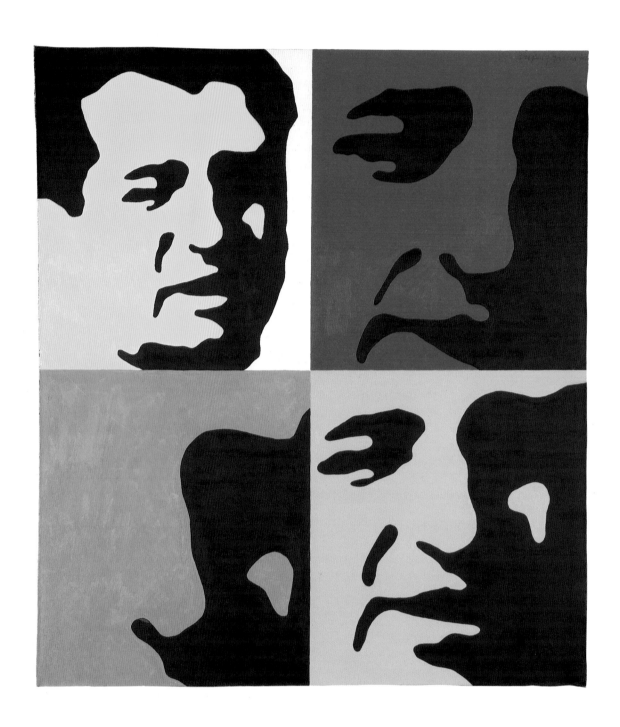

8. *Ruben Salazar*, 1970

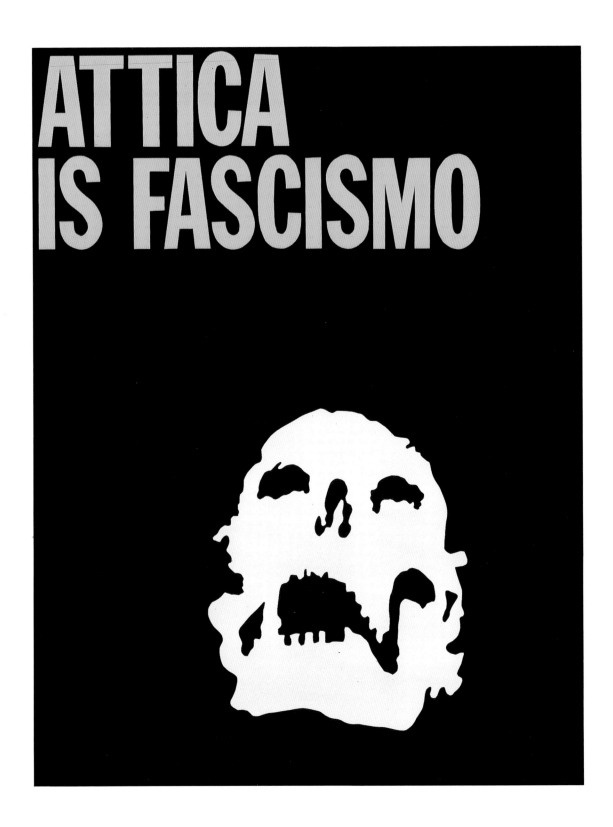

9. *Attica Is Fascismo*, 1971

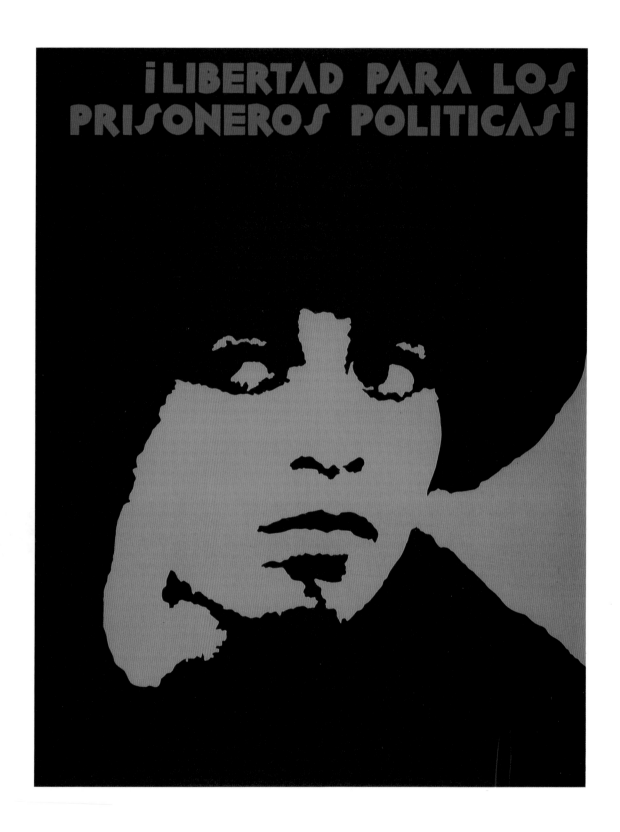

10. *Libertad para los Prisoneros Politicas,* 1971

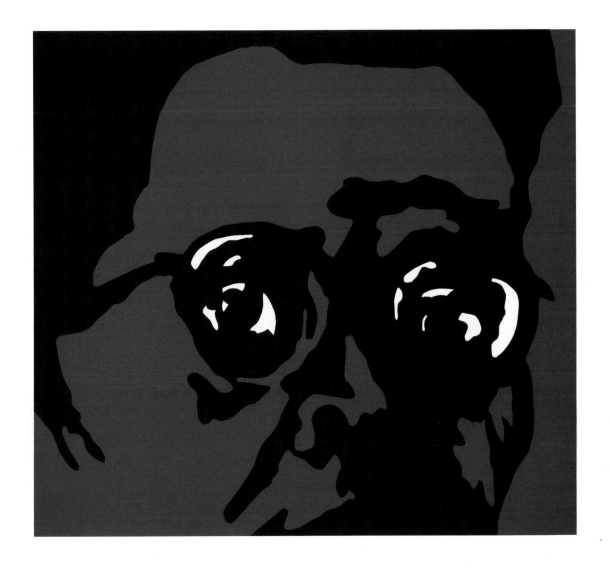

11. *Orozco,* 1973

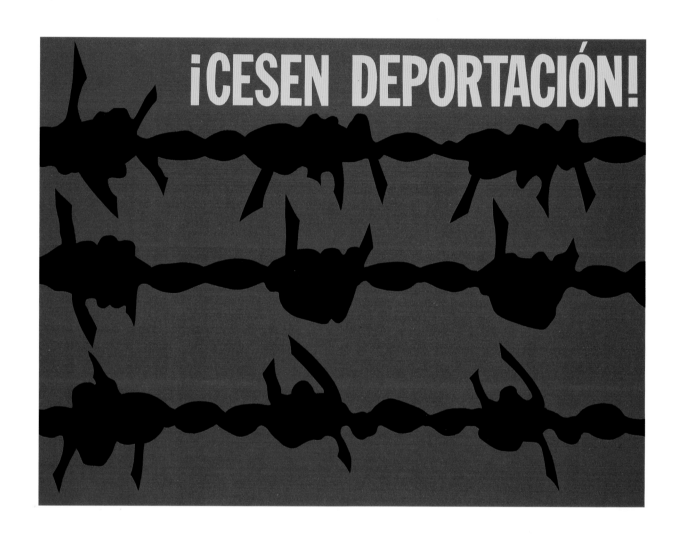

12. *Cesen Deportacion*, 1973

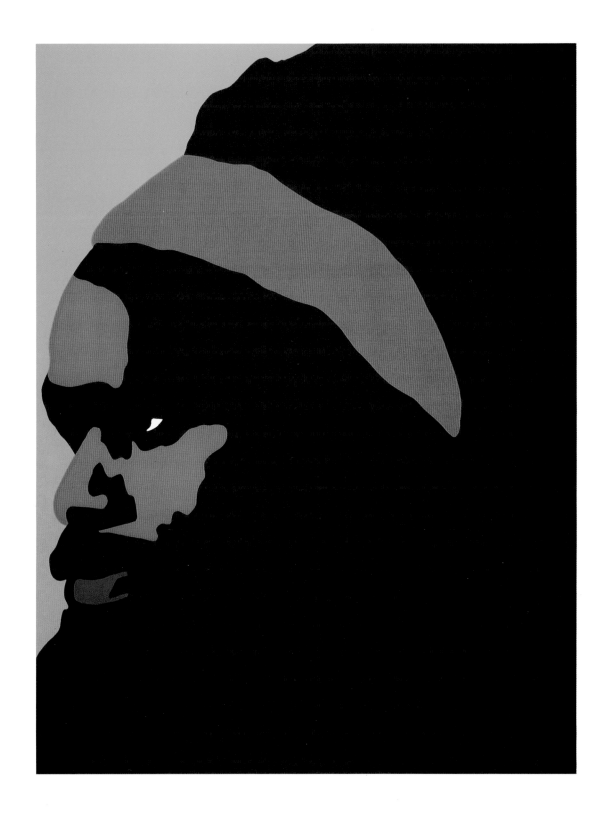

13. *Cambios*, 1972

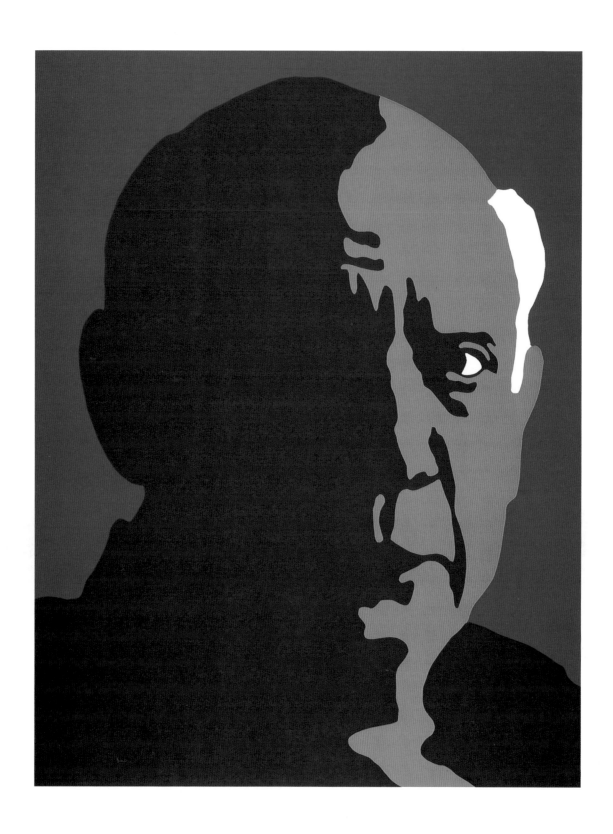

14. *Picasso,* 1973

15. *Maguey de la Vida,* 1973

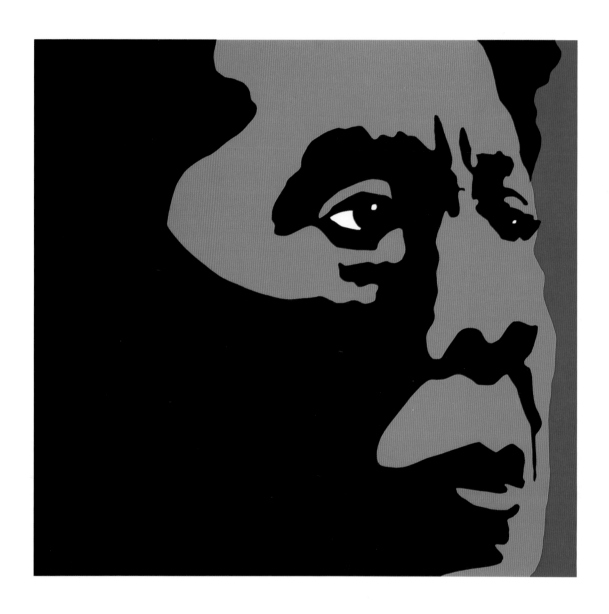

16. *Siqueiros,* 1974

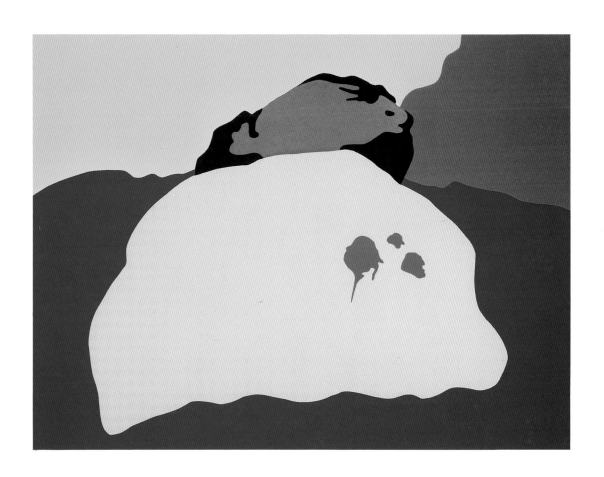

17. *The Bicentennial Art Poster,* 1975

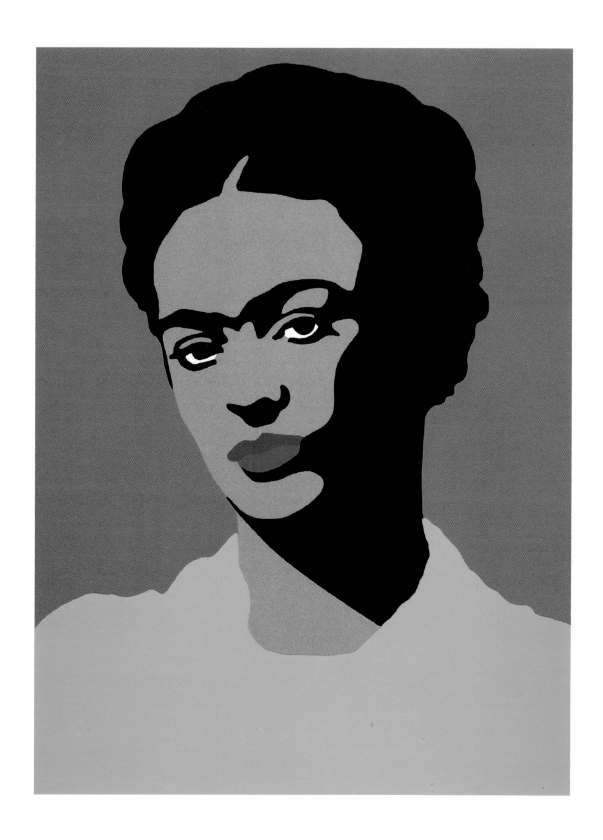

18. *Frida Kahlo*, 1975

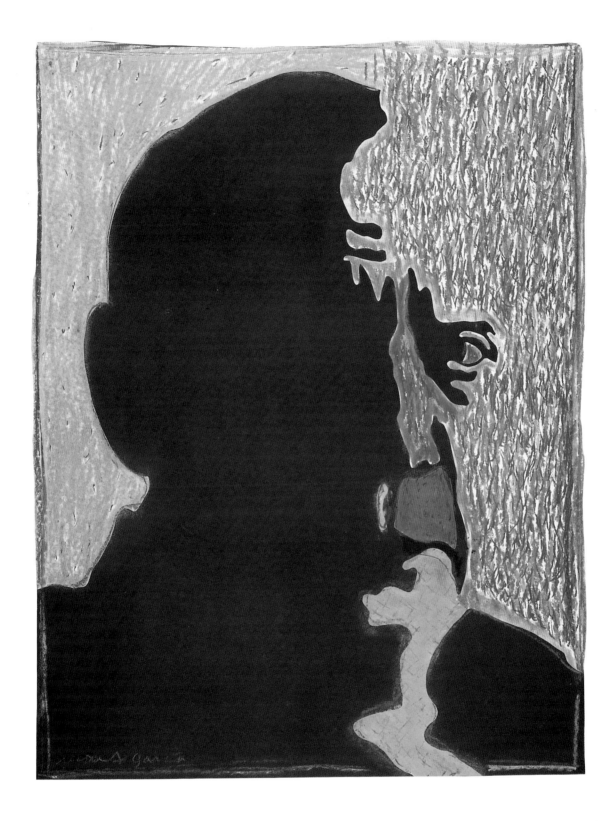

19. *Picasso,* 1973–75

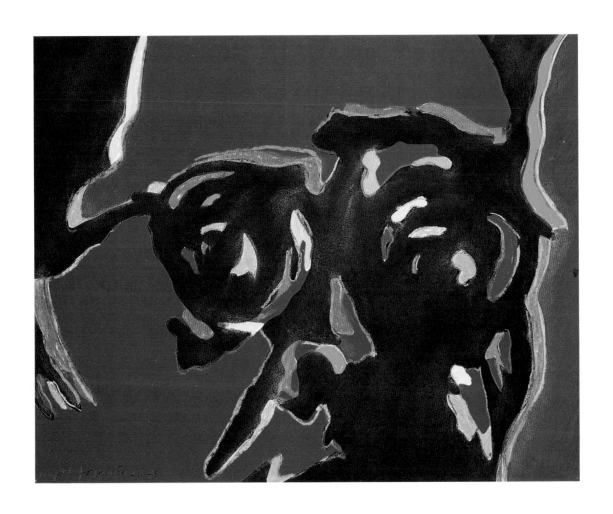

20. *Orozco, 1972–75*

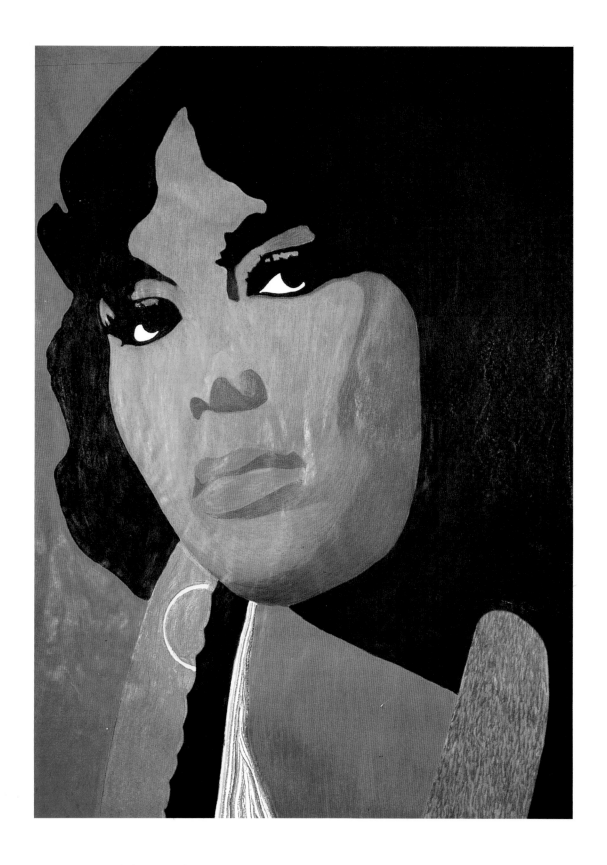

21. *Inez Garcia*, 1975–77

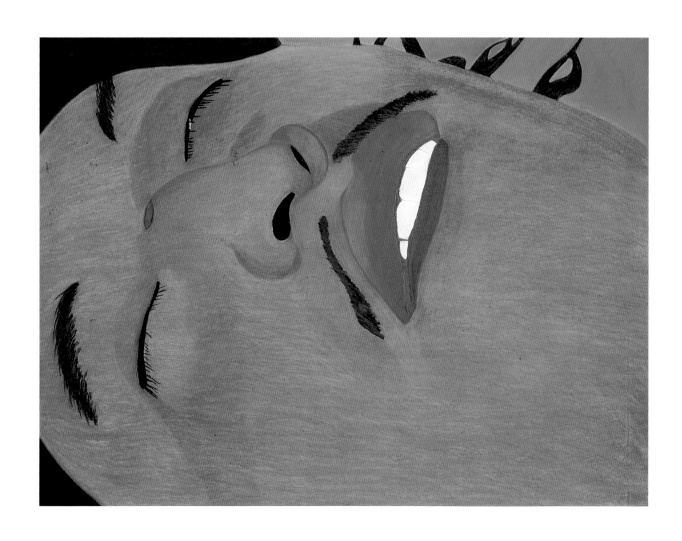

22. *Lucio Cabañas*, 1976

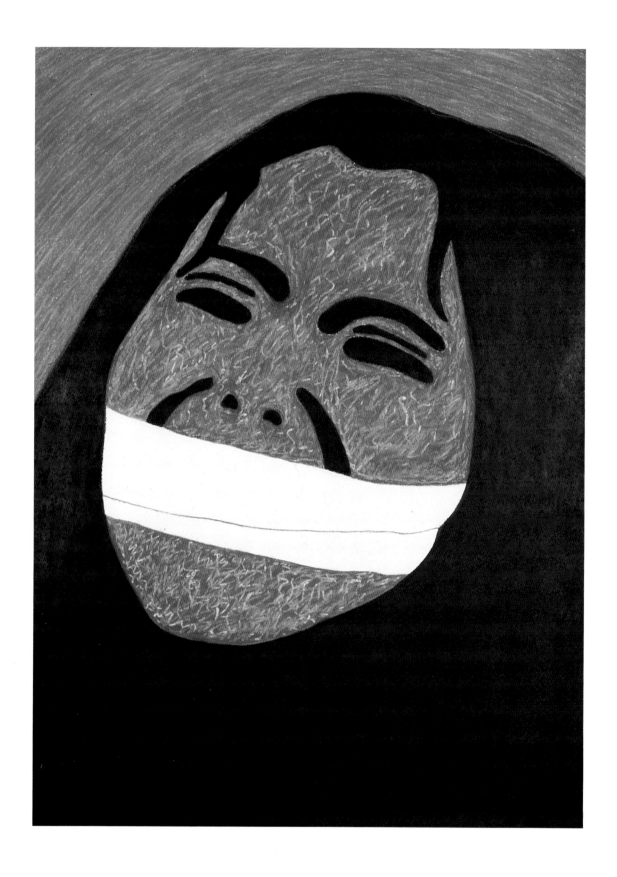

23. *Political Prisoner*, 1976

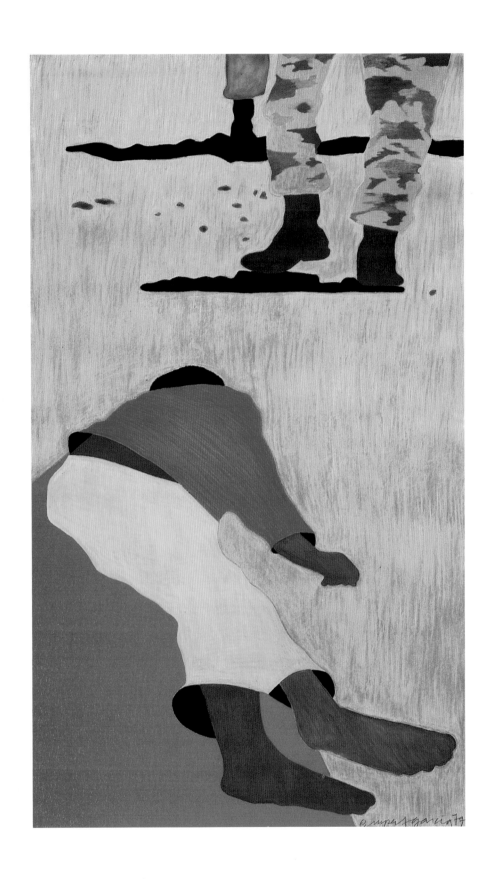

24. *Mexico, Chile, Soweto...*, 1977

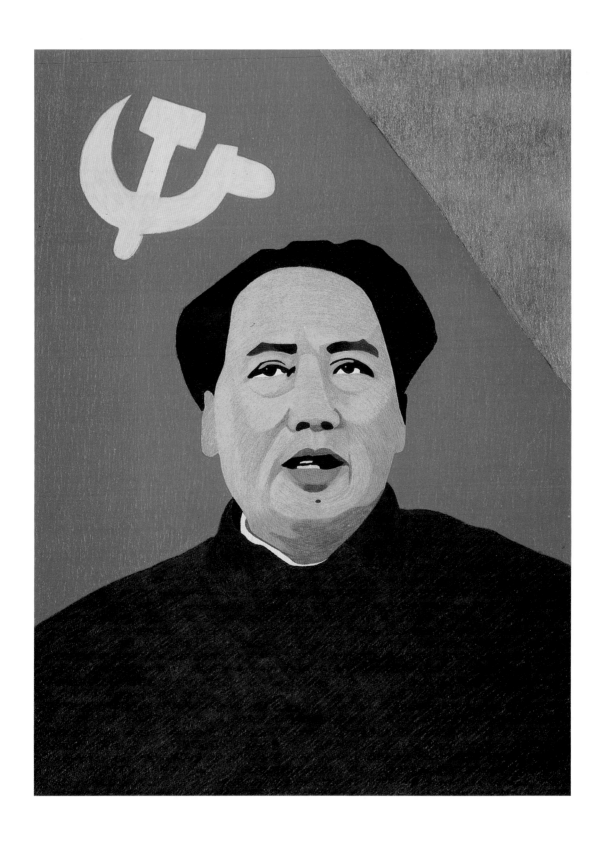

25. *Mao,* 1977

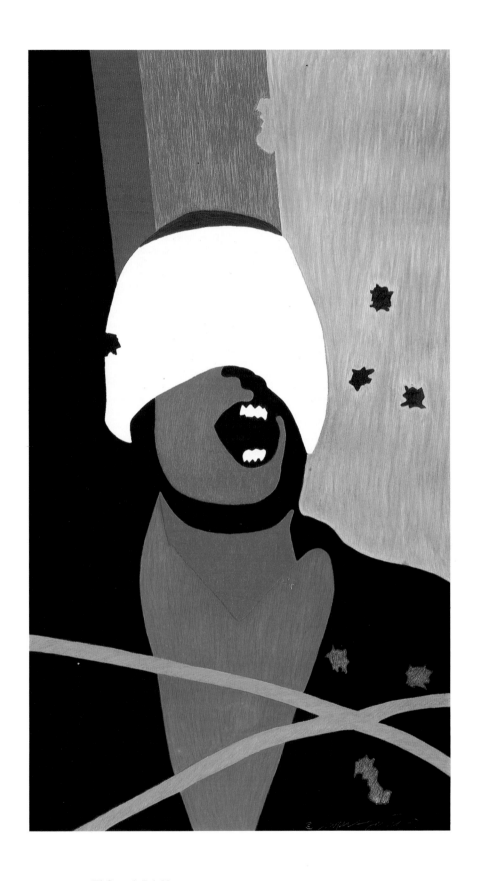

26. *El Grito de Rebelde*, 1978

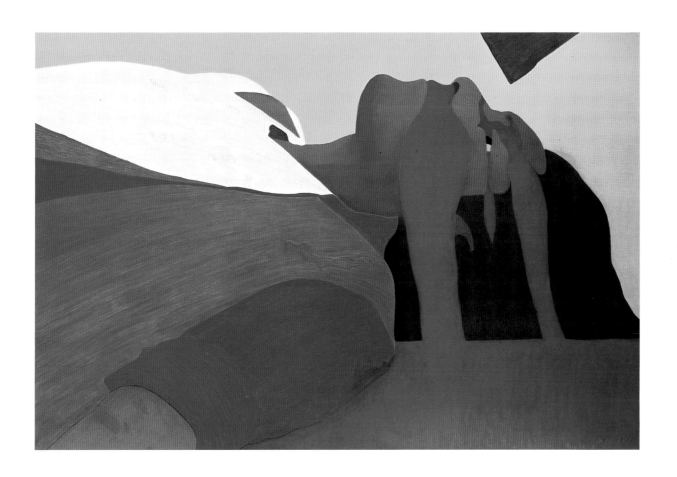

27. *Assassination of a Striking Mexican Worker*, 1979

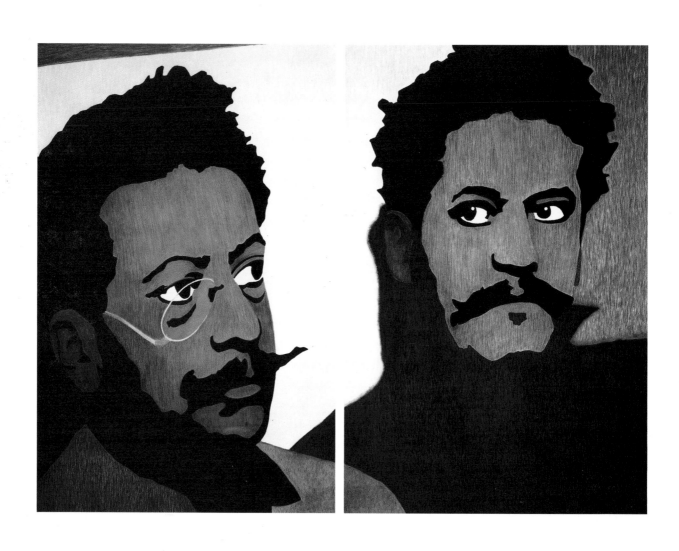

28. *Hermanos Flores Magon,* 1979–80

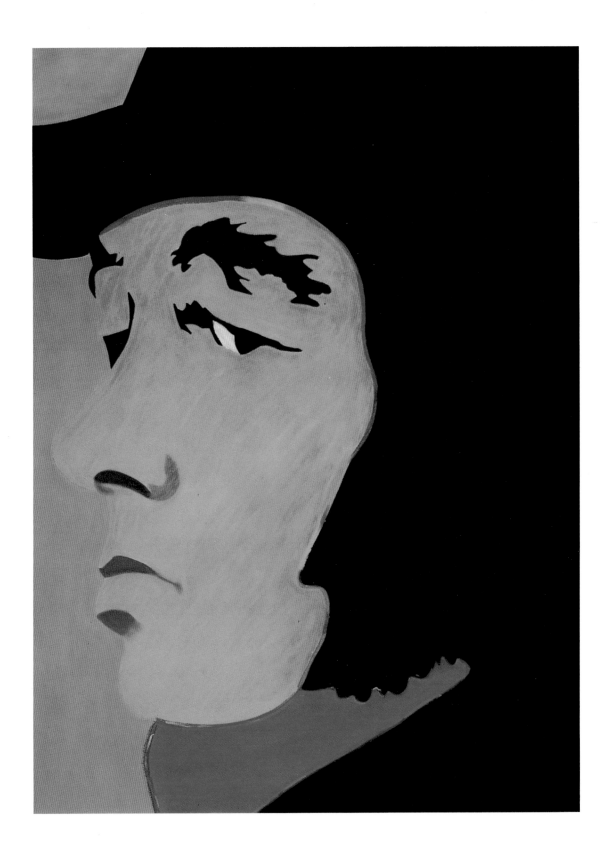

29. *Goya*, 1980

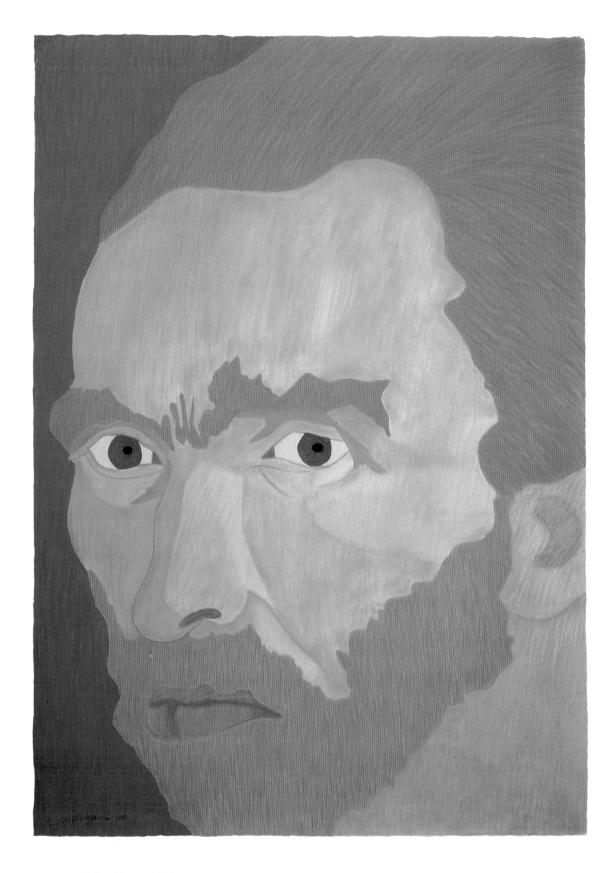

30. *Vincent,* 1980

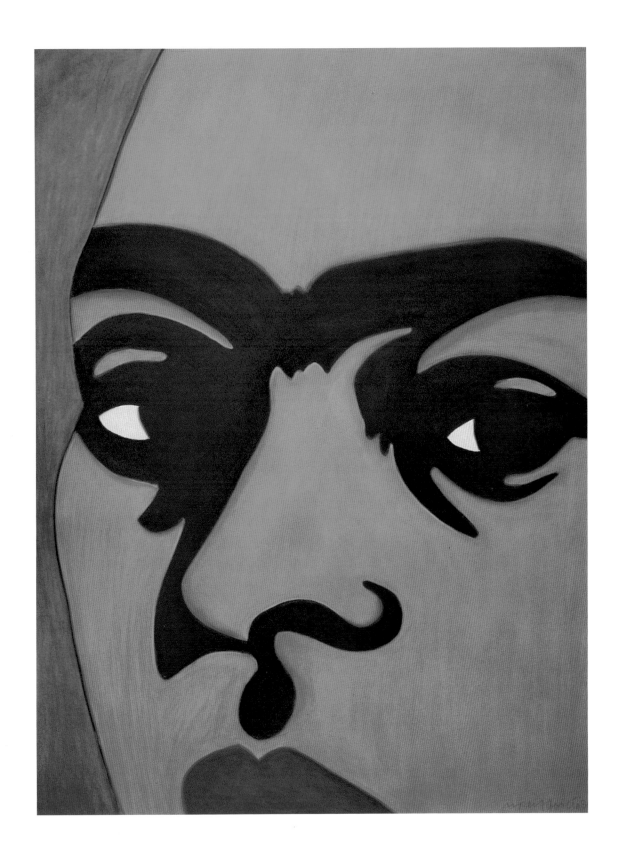

31. *Frida Kahlo*, 1980

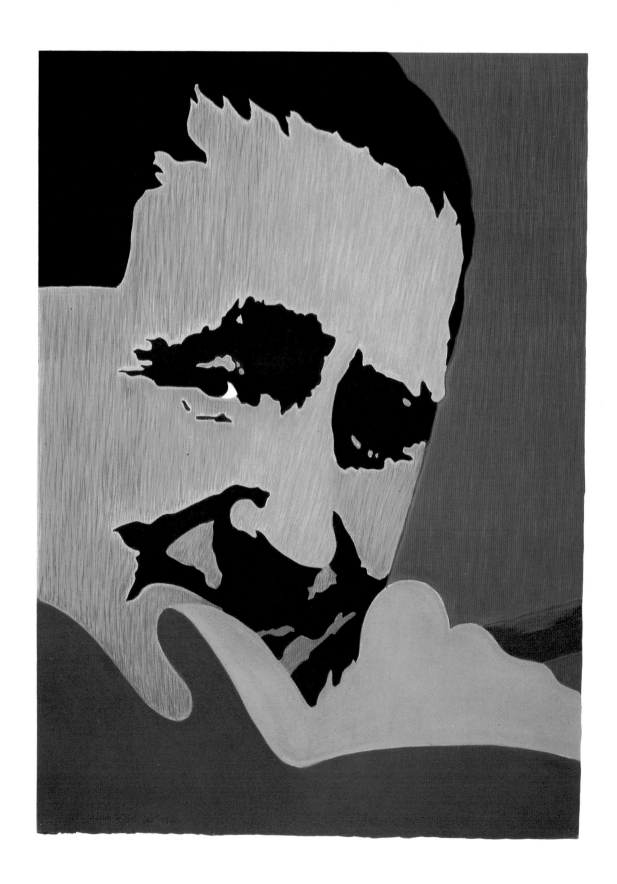

32. *Bertolt Brecht*, 1982

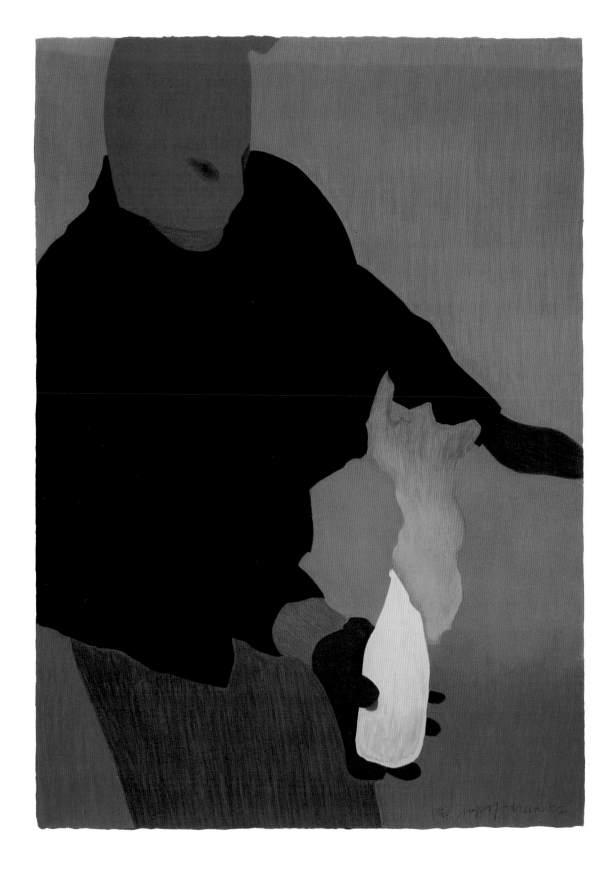

33. *Abanderado*, 1982

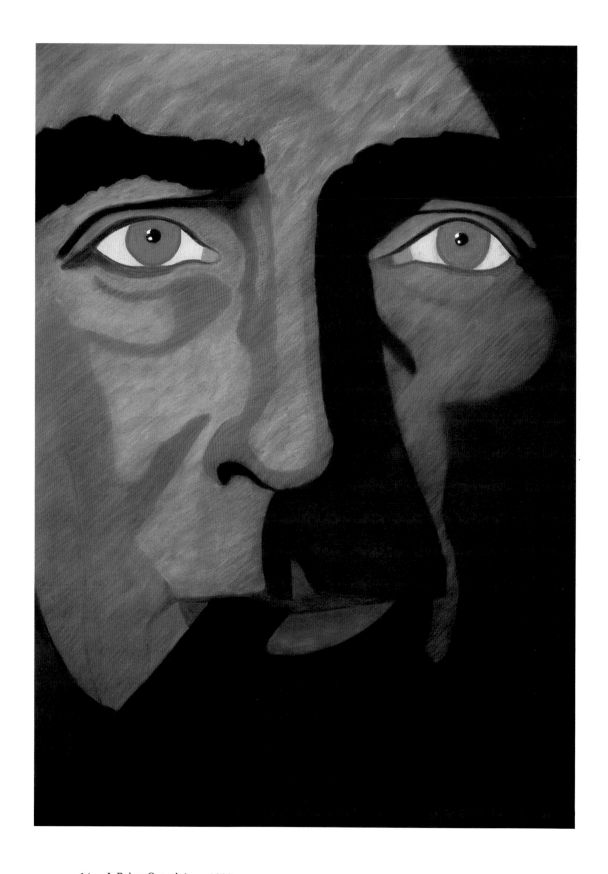

34. *J. Robert Oppenheimer*, 1982

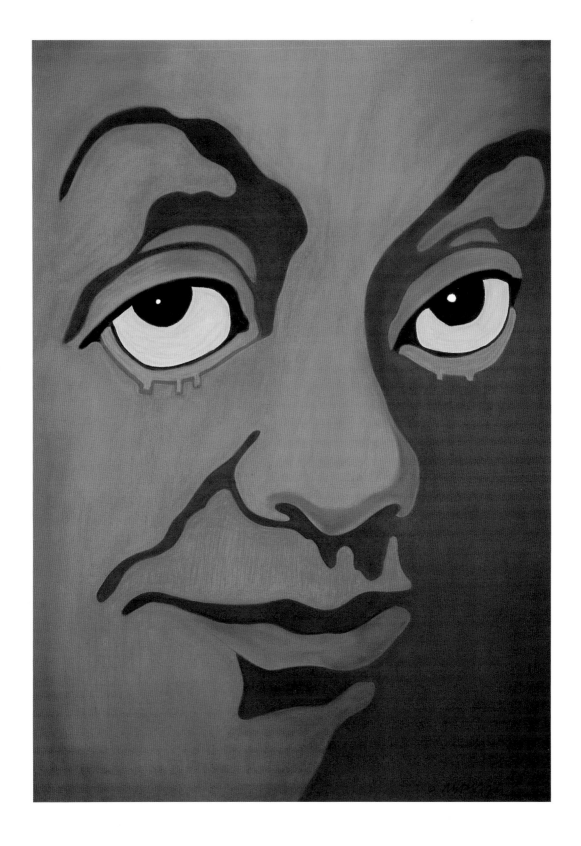

35. *Diego Rivera*, 1982

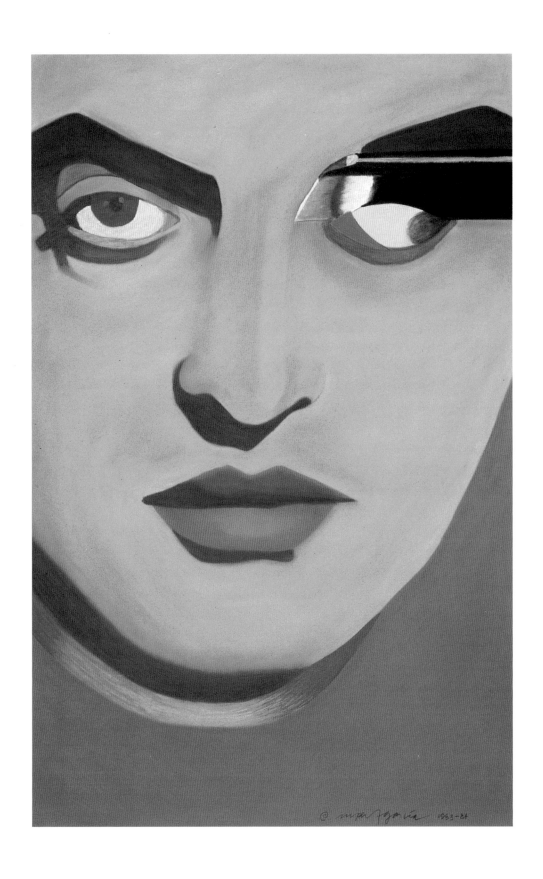

36. *Luis Buñuel*, 1983–84

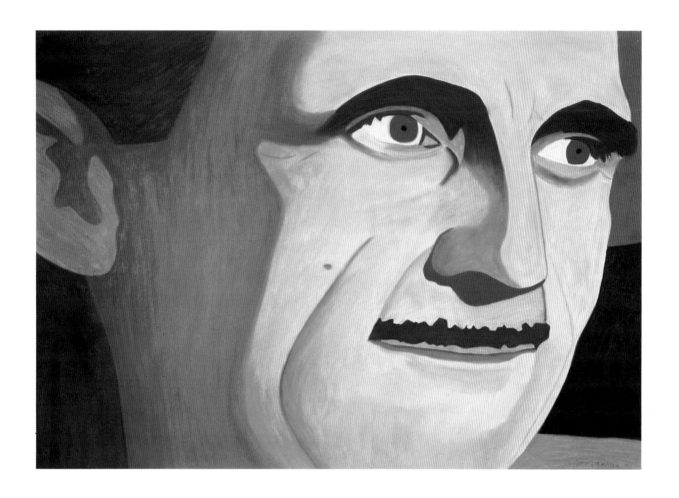

37. *My Name Is Not George Orwell*, 1984

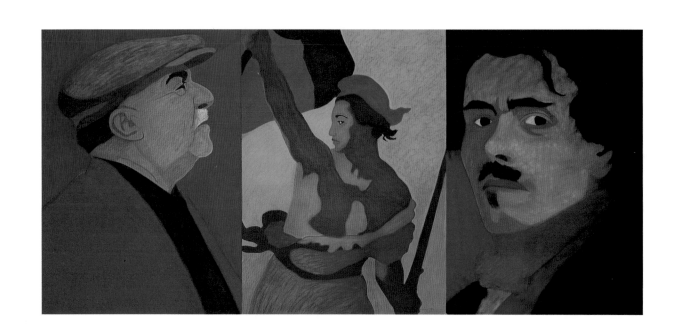

38. *Une Enigme / A Riddle*, 1984

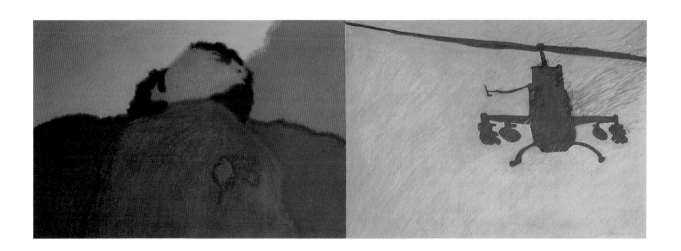

39. *Prometheus Under Fire,* 1984

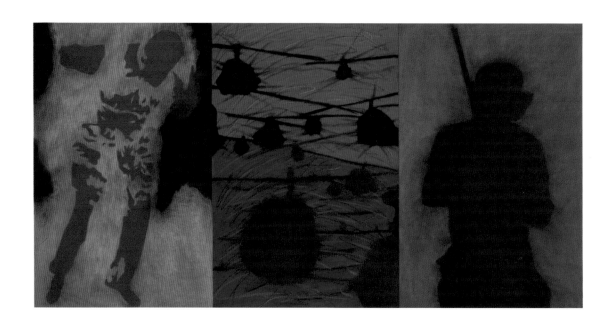

40. *Fenixes*, 1984

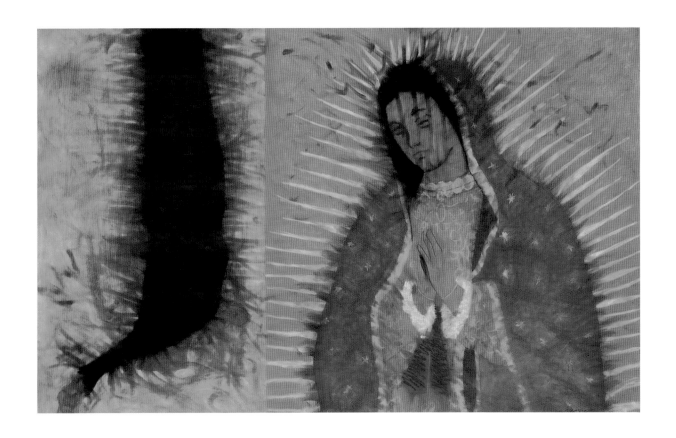

41. *La Virgen y Yo,* 1984

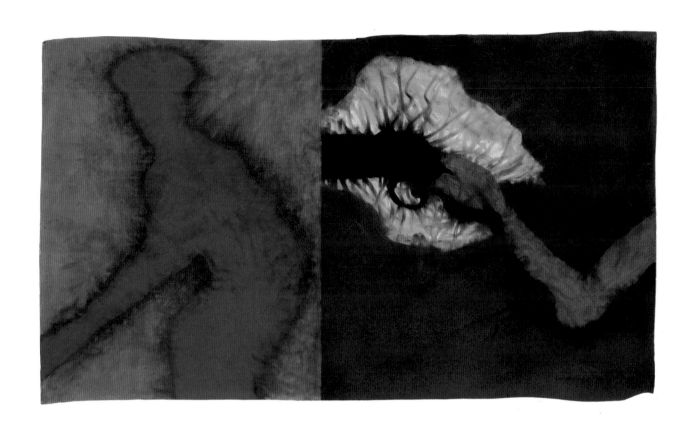

42. *Blue Man Fleeing Gun*, 1984

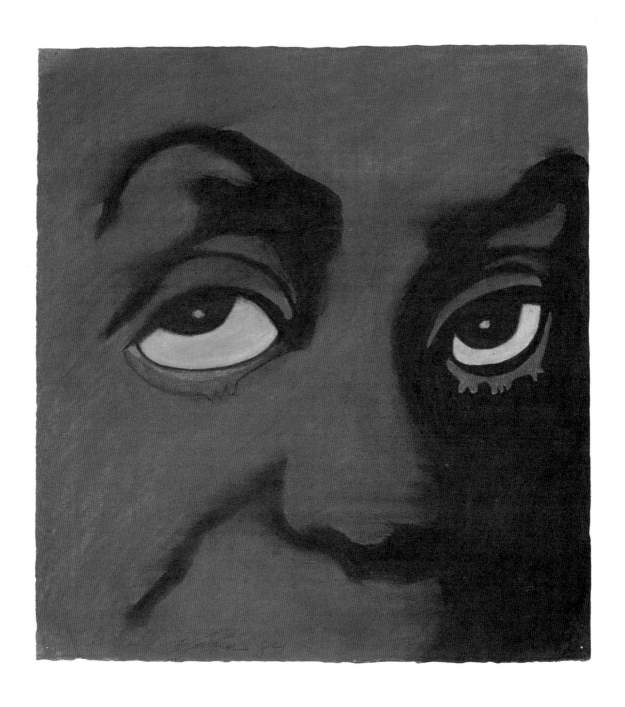

43. *Diego Rivera*, 1984

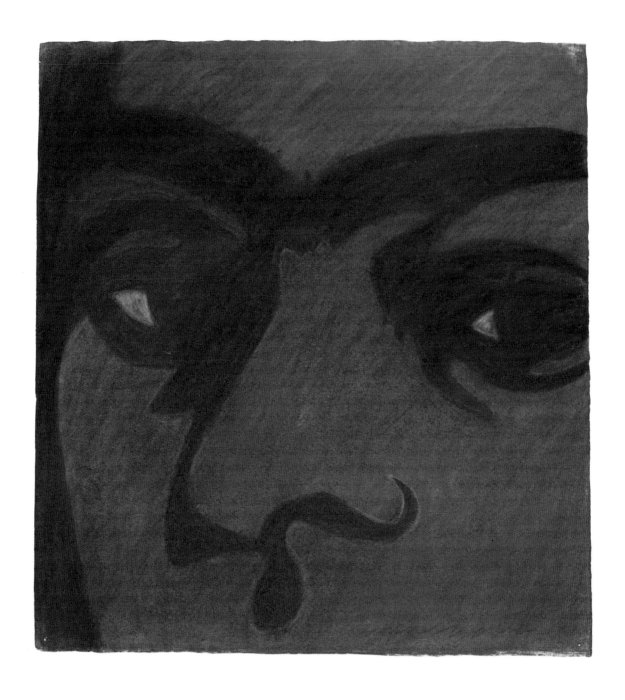

44. *Frida Kahlo*, 1984

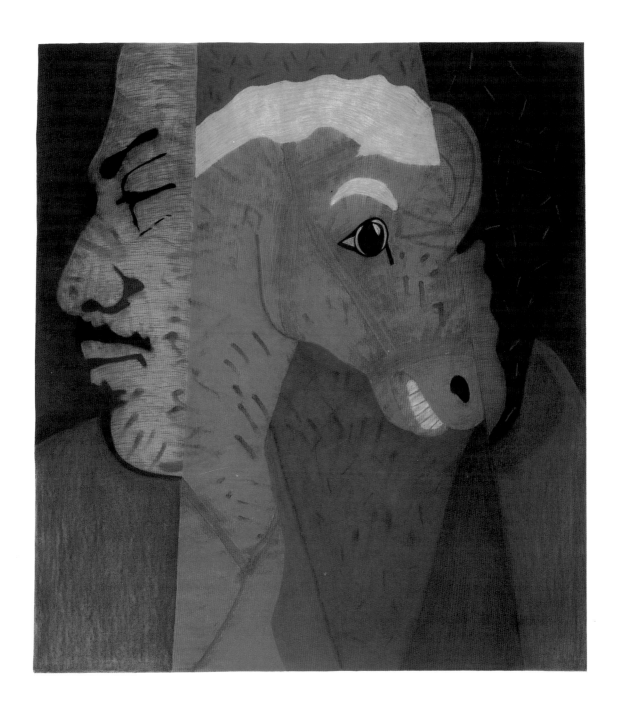

45. *The Horse in Man*, 1985

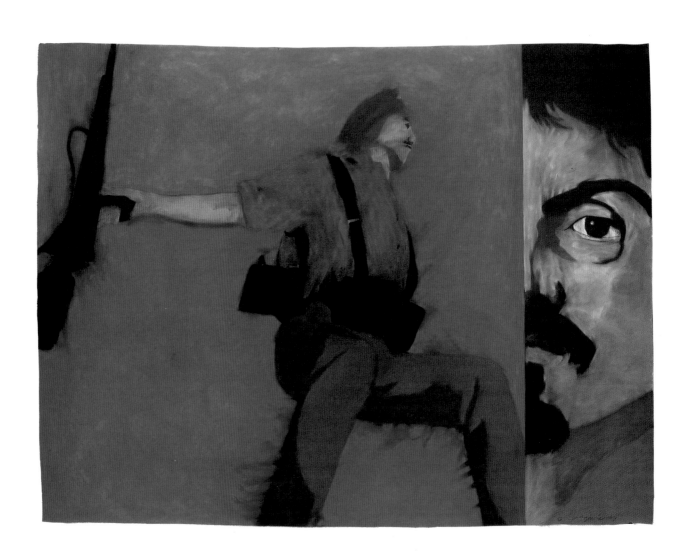

46. *For Caravaggio and the A.L.B.*, 1985

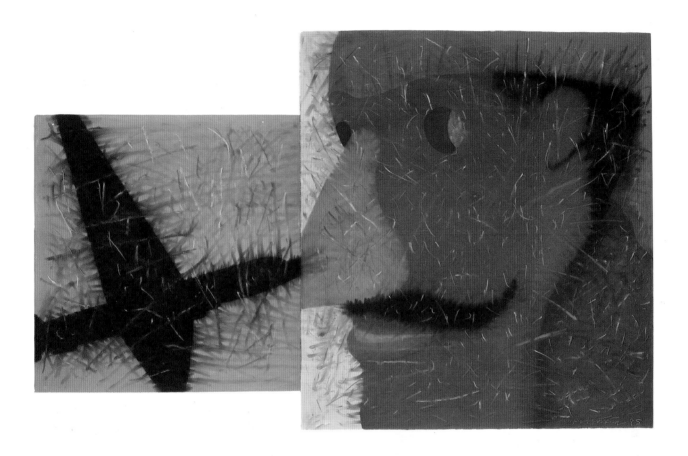

47. *Nose to Nose*, 1985

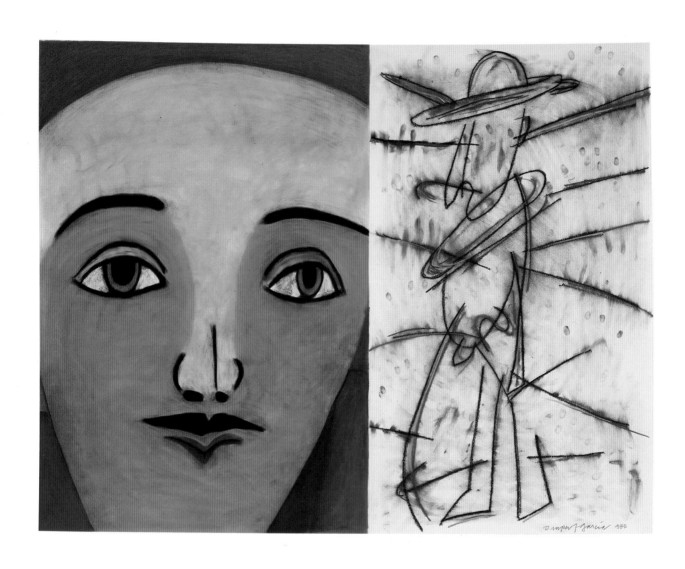

48. *Mascaranica*, 1985

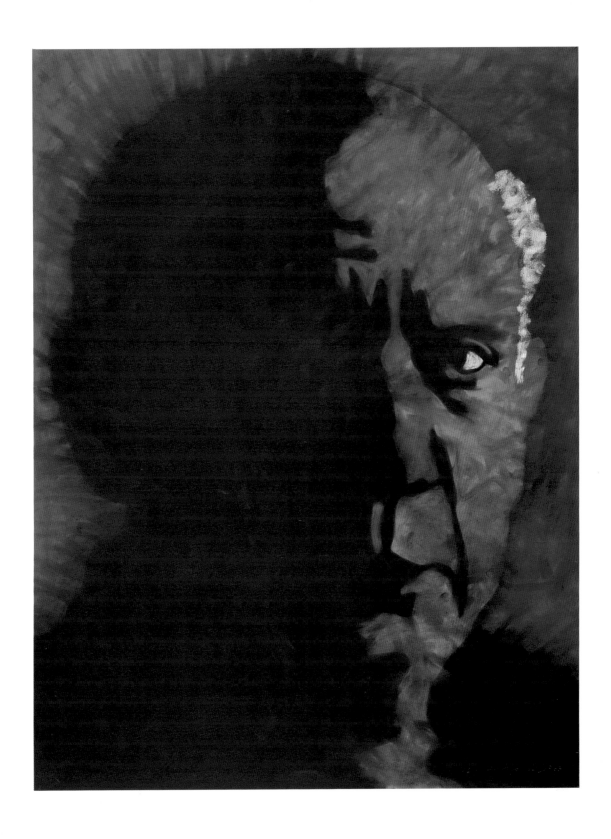

49. *Picasso,* 1985

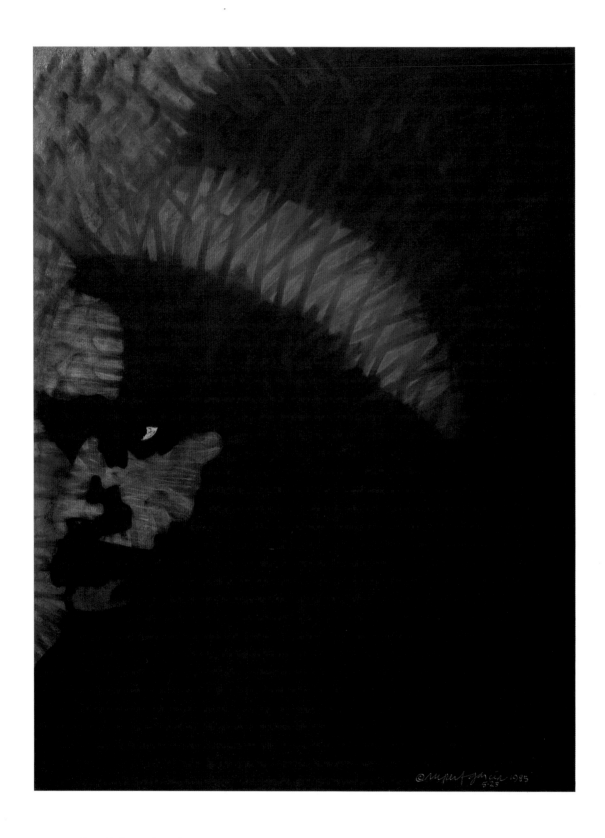

50. *Indigena Australiana*, 1985

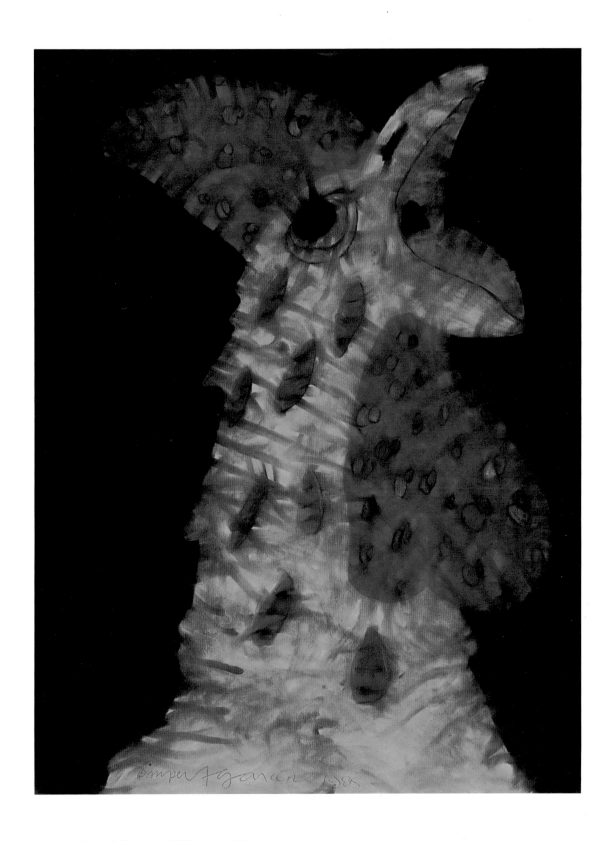

51. *A Sometime Self-Portrait*, 1985

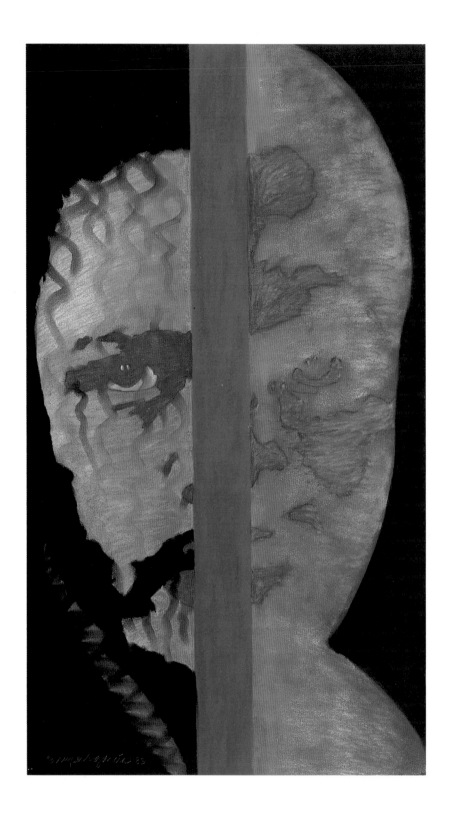

52. *S. Biko*, 1985

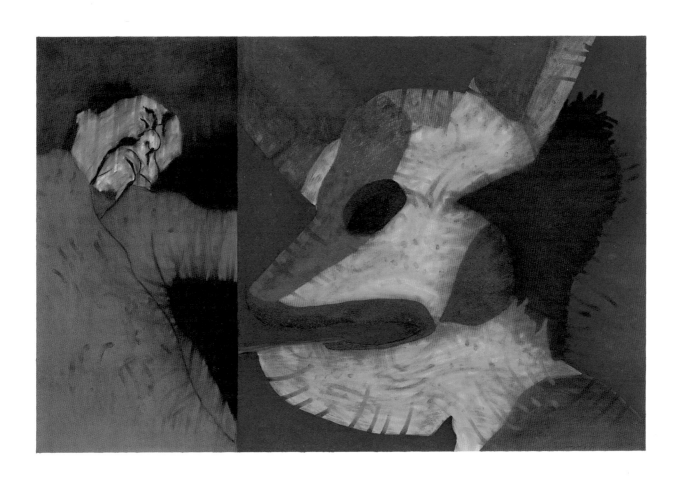

53. *Carnival of War*, 1985

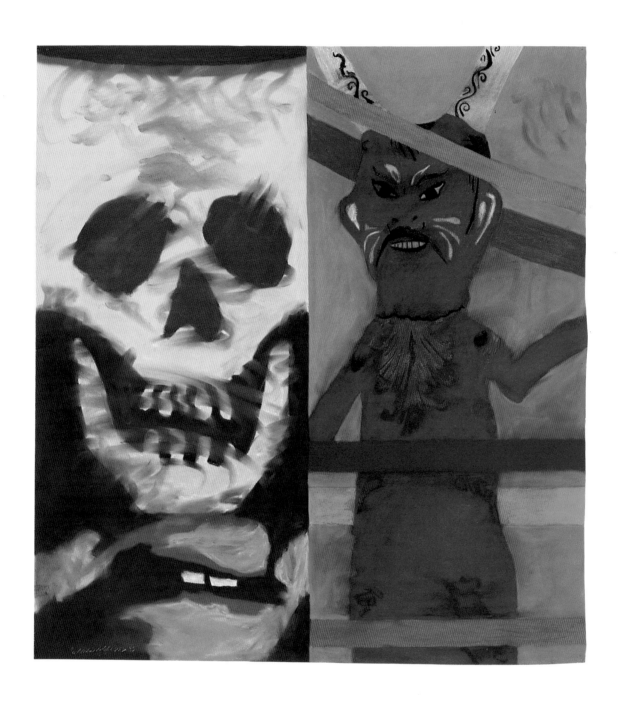

54. *Calavera y Diablo,* 1985

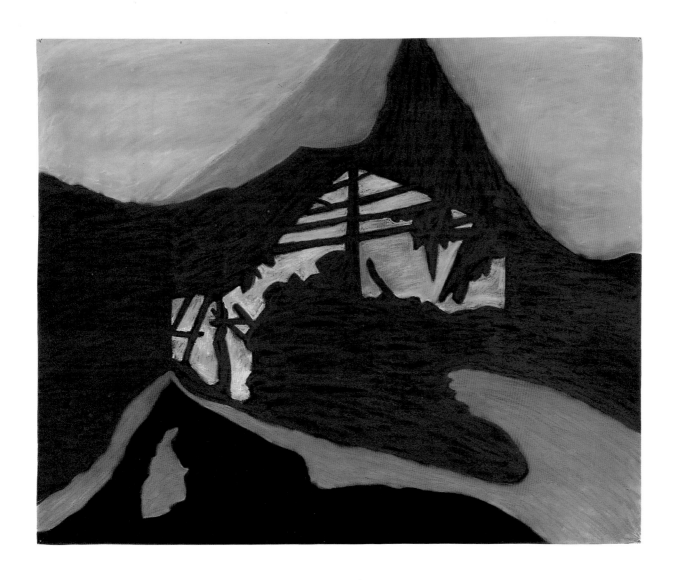

55. *Inside-Outside*, 1985

Checklist of the Exhibition

Dimensions are in centimeters, height precedes width. All works are courtesy of Sammi Madison-Garcia and Rupert Garcia unless otherwise noted.

1. *Unfinished Man*
 1968
 Acrylic on canvas
 122 x 122

2. *Untitled*
 1968
 Mixed media on illustration board
 56 x 43.2

3. *Right On*
 1968
 Silkscreen
 66 x 51
 The Oakland Museum

4. *Zapata*
 1969
 Silkscreen
 66 x 51

5. *Down with the Whiteness*
 1969
 Silkscreen
 66 x 51

6. *Fuera de Indochina*
 1970
 Silkscreen
 66 x 51

7. *Ruben Salazar Memorial Group Show*
 1970
 Silkscreen
 66 x 51

8. *Ruben Salazar*
 1970
 Acrylic on canvas
 137.2 x 122

9. *Attica Is Fascismo*
 1971
 Silkscreen
 66 x 51

10. *Libertad para los Prisoneros Politicas*
 1971
 Silkscreen
 66 x 51

11. *Orozco*
 1973
 Silkscreen
 36.7 x 45.6

12. *Cesen Deportacion*
 1973
 Silkscreen
 66 x 51

13. *Cambios*
 1972
 Silkscreen
 66 x 51

14. *Picasso*
 1973
 Silkscreen
 66 x 51

15. *Maguey de la Vida*
 1973
 Silkscreen
 66 x 51

16. *Siqueiros*
 1974
 Silkscreen
 66 x 51

17. *The Bicentennial Art Poster*
 1975
 Silkscreen
 66 x 51

18. *Frida Kahlo*
 1975
 Silkscreen
 58.3 x 44.4

19. *Picasso*
 1973–75
 Pastel over silkscreen
 66 x 51

20. *Orozco*
 1972–75
 Pastel over silkscreen
 36.7 x 45.6

21. *Inez Garcia*
 1975–77
 Pastel and poster paint on paper
 139 x 91.5
 Collection of James Bell and Francesca Lewis,
 San Francisco

22. *Lucio Cabañas*
1976
Pastel on paper
91.5 x 122
San Francisco Museum of Modern Art

23. *Political Prisoner*
1976
Pastel on paper
122 x 91.5
National Museum of American Art, Smithsonian
 Institution, Washington, D.C.

24. *Mexico, Chile, Soweto...*
1977
Pastel on paper
129.5 x 91.5
Courtesy of Harcourts Gallery, San Francisco

25. *Mao*
1977
Pastel on paper
129.5 x 91.5
Courtesy of Harcourts Gallery, San Francisco

26. *El Grito de Rebelde*
1978
Pastel on paper
167.5 x 89
Courtesy of Harcourts Gallery, San Francisco

27. *Assassination of a Striking Mexican Worker*
1979
Pastel on illustration board
107.7 x 152.5
Collection of Mr. and Mrs. Fred Banks,
 San Francisco

28. *Hermanos Flores Magon*
1979–80
Pastel on illustration board
152.5 x 203
Collection of Franklin Scarlata Dental
 Corporation, San Francisco

29. *Goya*
1980
Pastel on paper
106.6 x 75.6
Courtesy of Harcourts Gallery, San Francisco

30. *Vincent*
1980
Pastel on paper
106.6 x 75.6
Collection of Jeffrey S. Pollak, San Diego

31. *Frida Kahlo*
1980
Pastel on paper
101.7 x 76.2
Collection of Amalia Mesa-Baines and
 Richard Baines, San Francisco

32. *Bertolt Brecht*
1982
Pastel on paper
106.6 x 75.6
Collection of Peter and Carole Selz, Berkeley

33. *Abanderado*
1982
Pastel on paper
101.7 x 75.5
Collection of David and Janet Peoples, Berkeley

34. *J. Robert Oppenheimer*
1982
Pastel on paper
105.5 x 75
Collection of James Bell and Francesca Lewis,
 San Francisco

35. *Diego Rivera*
1982
Pastel on paper
105.5 x 75
The Mexican Museum, San Francisco

36. *Luis Buñuel*
1983–84
Pastel on paper
101.7 x 51
Courtesy of Harcourts Gallery, San Francisco

37. *My Name Is Not George Orwell*
1984
Pastel on paper
75.6 x 106.7
Courtesy of Harcourts Gallery, San Francisco

38. *Une Enigme/A Riddle*
1984
Pastel on paper
106.7 x 227.2
Collection of Mr. and Mrs. Edwin Raskin,
 Nashville

39. *Prometheus Under Fire*
1984
Pastel on paper
75.5 x 213
Courtesy of Harcourts Gallery, San Francisco

40. *Fenixes*
1984
Pastel on paper
106.7 x 224.2
Courtesy of Harcourts Gallery, San Francisco

41. *La Virgen y Yo*
1984
Pastel on paper
122 x 183
Collection of Dr. William H. Kroes, Los Angeles

42. *Blue Man Fleeing Gun*
1984
Pastel on paper
122 x 183
Courtesy of Harcourts Gallery, San Francisco

43. *Diego Rivera*
1984
Pastel on paper
40.8 x 38
Collection of Robert Marcus, San Francisco

44. *Frida Kahlo*
1984
Pastel on paper
40.8 x 38
Collection of Robert Marcus, San Francisco

45. *The Horse in Man*
1985
Pastel on paper
152 x 137
Collection of Gertie and Harold A. Parker,
 Tiburon, California

46. *For Caravaggio and the A.L.B.*
1985
Pastel on paper
123.2 x 160
Private collection

47. *Nose to Nose*
1985
Pastel on paper
152.5 x 244
Collection of Dennis Miller, Sanibel Island, Florida

48. *Mascaranica*
1985
Pastel on paper
100.2 x 142.3
Courtesy of Harcourts Gallery, San Francisco

49. *Picasso*
1985
Pastel on paper
122 x 91.5
Collection of Dr. John C. Kennady, Fountain Valley,
 California

50. *Indigena Australiana*
1985
Pastel on paper
122 x 91.5
Courtesy of Harcourts Gallery, San Francisco

51. *A Sometime Self-Portrait*
1985
Pastel on paper
122 x 91.5
Private collection

52. *S. Biko*
1985
Pastel on paper
84.1 x 48.2
Courtesy of Harcourts Gallery, San Francisco

53. *Carnival of War*
1985
Pastel on paper
122 x 183
Courtesy of Harcourts Gallery, San Francisco

54. *Calavera y Diablo*
1985
Pastel on paper
91.5 x 85
Courtesy of Harcourts Gallery, San Francisco

55. *Inside-Outside*
1985
Pastel on paper
98 x 119.5
Courtesy of Harcourts Gallery, San Francisco

Biography

Born in 1941 in French Camp, California

Education

Stockton College, Stockton, California, A.A., painting, 1962

San Francisco State University, B.A., painting, 1968; M.A., printmaking/silkscreen, 1970

University of California, Berkeley, doctoral studies in art education, 1973–75

University of California, Berkeley, M.A., history of modern art, 1981

Military Service

United States Air Force, 1962–66

Teaching

San Francisco State University, San Francisco, 1969–81
Department of Art (intermittent lecturer); La Raza Studies Program (art workshop, several semesters of history of Mexican art)

San Francisco Art Institute, San Francisco, 1973–80
Department of the Humanities (intermittent lecturer on history of Mexican art)

University of California, Berkeley, 1979–present
Chicano Studies Program (visiting lecturer on history of Mexican art and aspects of Chicano art); Department of Architecture (freehand drawing and elements of graphic design)

Mills College, Oakland, 1981
Ethnic Studies (instructor, Chicano poster making)

Washington State University, Pullman, 1984
Department of Comparative American Cultures (visiting assistant professor, history of Mexican art); Department of Fine Arts (introduction to art)

The Mexican Museum, San Francisco, 1986
California Arts Council Artist-in-Residence Grant (pastel painting and drawing)

Awards and Grants

1986 Artist-in-Residence Fellowship for 1987, Institute of Culture and Communication, East-West Center, Honolulu
San Francisco Arts Commission Award of Honor for Printmaking

1985 California Arts Council Artist-in-Residence Grant for 1986

1975 Photo Stencil, *Prints California*, Oakland Museum

1962 Frontier Award, Most Outstanding Art Student, Stockton College, Stockton, California

1960 Glick Jewelry Scholarship, Stockton, California

1959 First Place, Painting (category: 18–year–olds), Stockton Art Fair, Stockton, California

Public Collections

Achenbach Foundation, Palace of the Legion of Honor, San Francisco

Department of the Humanities, University of Minnesota, Minneapolis

Galeria de la Raza, San Francisco

National Museum of American Art, Smithsonian Institution, Washington, D.C.

The Oakland Museum

Ruben Salazar Library, Sonoma State University, Rohnert Park, California

San Francisco Museum of Modern Art

San Francisco State University Library

The Mexican Museum, San Francisco

University Art Museum, University of California, Berkeley

Exhibition History

Solo Exhibitions

1986 Basel Art Fair, Basel, Switzerland (catalogue)

1985 *Rupert Garcia: Paintings*, Harcourts Gallery, San Francisco (catalogue)

Rupert Garcia: Paintings, Traver/Sutton Gallery, Seattle

Rupert Garcia: Recent Pastels, UPB Gallery, Berkeley, California

1984 *Rupert Garcia: Matrix/Berkeley 79*, University Art Museum/Matrix, University of California, Berkeley (brochure)

1983 *Rupert Garcia: People in Pastels*, UPB Gallery, Berkeley, California

1982 Evergreen Galleries, Evergreen State College, Olympia, Washington

Plakatkunst Chicanos: Rupert Garcia und Malaquias Montoya, Klutertreff, Erlangen, West Germany

Rupert Garcia: Pastels, Simon Lowinsky Gallery, San Francisco

1981 *Portraits/Retratos*, The Mexican Museum, San Francisco (brochure)

Rupert Garcia, University Art Museum, State University of New York, Binghamton

1980 *Rupert Garcia: Poster and Silkscreen Art*, Coffman Gallery, University of Minnesota, Minneapolis (brochure)

1978 *Rupert Garcia: Pastel Drawings*, San Francisco Museum of Modern Art (catalogue)

1975 *Juan Fuentes and Rupert Garcia: Posters-Drawings-Prints*, Jackson Street Gallery, San Francisco

Juan Fuentes and Rupert Garcia: Posters-Drawings-Prints, Galeria de la Raza, San Francisco (brochure)

1972 *Graficos de Rupert Garcia y Ralph Maradiaga*, Galeria de la Raza, San Francisco

Saint Mary's College, Moraga, California

Serigrafia Posters by Rupert Garcia, Center for Chicano Studies, University of California, Santa Barbara

Universidad de Sonora, Hermosillo, Sonora, Mexico

1971 Deganawidah-Quetzalcoatl University, Davis, California

1970 *Posters by Rupert Garcia*, Artes 6, San Francisco

Serigraphs by Rupert Garcia, The Oakland Museum

Group Exhibitions

1986 *From Martin to Mandela, "The Struggle Continues"*, Watts Tower Center, Los Angeles

Crossing Borders/Chicano Artists, San Jose Museum of Art

1985 *Art in the San Francisco Bay Area, 1945–1980*, The Oakland Museum (catalogue)

Made in Aztlan, Centro Cultural de la Raza, San Diego

1984 *Crime and Punishment: Reflections of Violence in Contemporary Art*, Triton Museum, Santa Clara, California (catalogue)

The Human Condition: SFMMA Biennial III, San Francisco Museum of Modern Art (catalogue)

1983 *Rufino Tamayo: Painting and Mixographs*, The Mexican Museum, San Francisco

Das Andere Amerika, Staatliche Kunsthalle, Berlin (catalogue, traveling exhibition)

International Printmaking Invitational, Art Gallery, California State College, San Bernardino (catalogue)

A Traves de la Frontera, Sala de Exposiciones del Centro de Estudios Economicos y Sociales del Tercer Mundo, Mexico (catalogue, traveling exhibition)

Art for People's Sake: Political Art Exhibit/Benefit Sale for the National Lawyer's Guild, Media Resource Center, Fort Mason Center, San Francisco

1982 *San Francisco State University Strike Poster Workshop*, Student Union Depot Art Gallery, San Francisco State University

Califas: Works on Paper, Fondo de Sol, Washington, D.C.

Posters by Fine Art Support Organizations, Sun Gallery, Hayward, California

Grand Oak Gallery, Oakland

Cinco de Mayo Inaugural Exhibit at the Fort Mason Center, The Mexican Museum, San Francisco (brochure)

California Art on the Road, Laguna Beach Museum of Art, California (catalogue, traveling exhibition)

1981 *Califas: An Exhibition of Chicano Artists in California*, Mary Porter Sesnon Art Gallery, University of California, Santa Cruz

1980 *Fifth Anniversary Exhibit: Los Primeros Cinco Anos*, The Mexican Museum, San Francisco (brochure)

A Decade in Flight, Galeria de la Raza, San Francisco

Mosaic: A Multicultural Art Exhibition, Memorial Union Art Gallery, University of California, Davis (brochure)

Cinco de Mayo Art Exhibition, The Cannery, San Francisco

1979 *Ten X Ten, The Oakland Museum: The First Decade*, The Oakland Museum

8 Artistas de San Francisco—Paintings and Graphics, Ruben Salazar Library, Sonoma State University, Rohnert Park, California

1978 *Graphica Creativa '78*, Alvar Aalto Museum of Central Finland, Jyvaskyla (catalogue)

Reflexiones: A Chicano-Latino Art Exhibition, El Centro Cultural de la Raza, San Diego

Political Posters by San Francisco Poster Makers, Helen Euphart Gallery, De Anza College, Cupertino, California

2nd South-Western Chicano Invitational, Heard Museum, Phoenix (catalogue)

Mexposicion III La Mujer: A Visual Dialogue, Chicago Public Library Cultural Center

Mexican American Artists of the San Francisco Bay Area, The Mexican Museum, San Francisco

Latin American Works from the Permanent Collection, San Francisco Museum of Modern Art

Homenaje a Frida Kahlo, Galeria de la Raza, San Francisco (catalogue)

1977 *Political Poster Show: The Work of Poster Makers in San Francisco 1977*, Capricorn Asunder, San Francisco Arts Commission Gallery

Mission Cultural Center, San Francisco

Cinco de Mayo, Foothill Junior College, Los Altos Hill, California

Razarte: Cinco de Mayo, San Francisco State University

Downtown Dog Show, Downtown Center, The Fine Arts Museums of San Francisco

Posters: An Exhibition of Poster Art From Local Community Groups and Designers, North Oakland Welfare Office, Oakland

Prelude to the Fifth Sun/Traditional Chicano and Latino Art, University Art Museum, University of California, Berkeley (catalogue, traveling exhibition)

Raices Antiguas/Visiones Nuevas, Tucson Museum of Art, Arizona (catalogue, traveling exhibition)

1976 *Other Sources: An American Essay*, San Francisco Art Institute (catalogue)

Bay Area La Raza Artists, Student Union Gallery, San Francisco State University

Cinco de Mayo I, Chabot College Library, Chabot College, Hayward, California (brochure)

Arte Picante, Mandeville Art Gallery, University of California, San Diego

Art and Revolution, Fellowship Hall, Glide Memorial Church, San Francisco (brochure)

Impressions: California Print Invitational, Ohlone College, Fremont, California (catalogue)

1975 *Chicanarte*, Los Angeles Municipal Art Gallery (catalogue)

Chicano Posters, Escuela de Diseno y Artesanias, Mexico City

Dia de los Muertos, Galeria de la Raza, San Francisco

Images of an Era: The American Poster 1945–1975, Corcoran Gallery of Art, Washington, D.C. (catalogue, traveling exhibition)

Prints of California, Oakland Museum (catalogue, traveling exhibition)

Stuart, Kokin, and Garcia, La Pena, Oakland, California

1974 *Chicano Art*, The Gallery, Santa Ana College, California (brochure)

Chicano Graficos... California, Southern Colorado State College, Pueblo, Colorado (catalogue)

M.I.X. Graphics I: Prints, San Francisco Museum of Modern Art (brochure)

Festival del Sexto Sol, San Francisco Palace of Fine Arts

Third World Art Show, Gallery Lounge, San Francisco State University

National Print Invitational Exhibition 1974, Main Art Gallery, Sacramento State University, California (brochure)

San Francisco Arts Festival, San Francisco Civic Center

Posters and Society, San Francisco Museum of Modern Art (brochure)

1973 *Benefit Show for Nicaraguan Earthquake Victims*, Galeria de la Raza, San Francisco

Conferencia Artistas de Aztlan, Jamestown Center, San Francisco

Alumni House, University of California, Berkeley

San Francisco Arts Festival, San Francisco Civic Center

Allende/Neruda Memorial Poetry Reading, Glide Memorial Church, San Francisco

A Visual Documentary of the Mission District by Members of the Galeria de la Raza, Galeria de la Raza, San Francisco

Faculty Show, San Francisco State University

International Art Exhibit for the Defense of Political Prisoners, Cody's Bookstore, Berkeley, California (brochure, traveling exhibition)

1972 *Third World Student Exhibition*, Diego Rivera Gallery, San Francisco Art Institute (guest exhibitor)

Semana de la Raza Exhibit, Mulberry Union Gallery, University of California, San Francisco

1971 Los Angeles Print Society Annual Exhibit

Hartnell College, Salinas, California

Chicano Art Symposium, International Institute of Los Angeles

1970 *War Protest Exhibit*, First Unitarian Church, San Francisco

National Drawing Exhibition, San Francisco Museum of Modern Art (catalogue)

The Pollution Show, The Oakland Museum (catalogue)

San Francisco Arts Festival, San Francisco Civic Center

Invitational Chicano Art Exhibit, Sacramento State College, California

Dia de la Raza, Santa Barbara Museum of Art, California

Galeria de la Raza, San Francisco

1969 *Can Art Be Relevant to the Social and Political Conditions of Man*, Mulberry Union Gallery, University of California, San Francisco

University of California, Santa Barbara

Faculty Show, San Francisco State University

San Francisco Arts Festival, San Francisco Civic Center

Artes de Barrio, Mission Adult Center, San Francisco (traveling exhibition)

1968 *San Francisco Arts Festival*, San Francisco Civic Center

Apostrophe S, San Francisco

1962 Papa's Pizza, San Francisco

Bibliography

About the Artist

1986 O'Connor, Francis V. "The Influence of Diego Rivera on the Art of the United States during the 1930s and After," in *Diego Rivera: A Retrospective*. Detroit and New York: Detroit Institute of Arts and W. W. Norton, 1986

 Tarshis, Jerome. "Review of Exhibitions: San Francisco—Rupert Garcia at Harcourts." *Art in America*, February 1986

1985 Albright, Thomas. *Art in the San Francisco Bay Area, 1945–1980*. Berkeley: University of California Press, 1985

 Baker, Kenneth. "Garcia Pastels Treat Art as Ammo." *San Francisco Chronicle*, September 12, 1985

 Berlin, Mark. "Softly Revolutionary Rupert." *The Berkeley Voice*, April 3, 1985

 Burkhart, Dorothy. "Critics Choice." *Arts and Books* (supplement of *San Jose Mercury News*), September 15, 1985

 Burnson, Patrick. "Rupert Garcia in Major Show." *People's World*, September 21, 1985

 Goldman, Shifra M., and Ybarra-Frausto, Tomas. *Arte Chicano: A Comprehensive Annotated Bibliography of Chicano Art, 1965–1981*. Chicano Studies Library Publication Series, no. 11, Berkeley: University of California, 1985

 Hopkins, Henry T. Foreword in *Rupert Garcia*. San Francisco: Harcourts Gallery, 1985

 Marks, Laurie. "Profiles: Rupert Garcia." *Metier*, Spring 1985

 Marvel, Bob. "Rupert Garcia: Personalized Politics." *La Voz*, June/July 1985

 Selz, Peter. *Rupert Garcia*. San Francisco: Harcourts Gallery, 1985

1984 Albright, Thomas. "Letting the Art Fit the Crime." *Review* (supplement of the *San Francisco Sunday Examiner and Chronicle*), March 18, 1984

 Barnett, Alan W. *Community Murals*. Philadelphia: The Art Alliance Press, 1984

 Berlin, Mark. "Portraits and Politics: Garcia at the UAM Matrix." *The Berkeley Voice*, December 12, 1984

 Burkhart, Dorothy. "Protest Art from Garcia." *San Jose Mercury News*, December 14, 1984

 _____. "Violence Colors Artworks: Crime and Punishment Attacks Urban Epidemic." *San Jose Mercury News*, March 9, 1984

 Goldman, Shifra M. "A Public Voice: Fifteen Years of Chicano Posters." *Art Journal*, Spring 1984

 Hopkins, Henry T. Introduction to *The Human Condition: SFMMA Biennial III*. San Francisco: San Francisco Museum of Modern Art, 1984

 Lewallen, Constance. "Powerful Pastels." *University Art Museum Berkeley Calendar*, December 1984

 _____. *Rupert Garcia: Matrix/Berkeley 79*, Berkeley: University Art Museum, 1984

 Martini, Chris. "California Letter: Crime and Punishment in Silicon Valley." *Studio International*, vol. 197, no. 1005, 1984

 Obenland, Kathleen. "Visiting Professor Makes Statements in Art." *Daily Evergreen*, February 21, 1984

 Orr-Cahall, Christina, ed. *The Art of California: Selected Works from the Collection of the Oakland Museum*. Oakland and San Francisco: The Oakland Museum Art Department and Chronicle Books, 1984

 Roder, Sylvia. "No Easy Way to Catharsis." *Artweek*, March 24, 1984

 Van Proyen, Mark. "Metaphor and Ideology." *Artweek*, December 22, 1984

1983 Albright, Thomas. "Rupert Garcia: Radical Political Portraits." *San Francisco Chronicle*, April 28, 1983

 _____. "The Sunny Outlook of Rufino Tamayo." *San Francisco Chronicle*, June 23, 1983

 Ernst, Margo. "Mexican Artist Subject of Local Man's Book." *The Stockton Record*, October 23, 1983

 Pflaum, David. "Political Portraiture: Rupert Garcia's Posters and Pastels." *Daily Californian*, April 29, 1983

 Shere, Charles. "Gallery Roundup." *The Tribune*, May 13, 1983

1982 E. B. "Die Strabe als Galerie: Plakatkunst der Chicanos aur Zeit im Kulturtreff in der Helmstrabe." *Erlangen Tablatt*, May 20–21, 1982

Goldman, Shifra M. "Califas en Santa Cruz" (part one). *La Communidad* (Sunday supplement of *La Opinion*), January 31, 1982

_____. "Califas en Santa Cruz" (part two). *La Communidad*, February 2, 1982

Prior, Katherine. "Califas." *Latino*, April 1982

Pwyplat, Lisa. "Plakatkunst der Chicanos." *Tendenzen*, September 1982

1981 Alacron, Francisco X., Herrera, Juan F., and Martinez, Victor. "Portraits Plus Struggles Plus Consciousness: Nine Pastels by Rupert Garcia." *Metamorfosis*, vol. 3, no. 2; vol. 4, no. 1, 1980–81

Albright, Thomas. "Anonymous Martyrs and Geometric Lobby Decor." *San Francisco Chronicle*, January 26, 1981

Atkins, Robert. "Mexican Geometrics and Political Portraits." *The San Francisco Bay Guardian*, February 4–11, 1981

Burkhart, Dorothy. "Chicano Pride and Anger Mix at 'Califas.'." *San Jose Mercury News*, April 12 (Sunday), 1981

de Lappe, Pele. "From Pen to U.N.: Saga of Rupert Garcia's Poster." *People's World*, July 11, 1981

Goldman, Shifra M. "Chicano Art—Looking Backward." *Artweek*, June 20, 1981

Siquenza, Herbert. "Local Artists Exhibit Their Works." *El Tecolote*, February 1981

1980 Gordon, Allan M. "A Mosaic of Cultures." *Artweek*, February 2, 1980

1979 Charlot, Jean. "Posada and His Successors," in *Posada's Mexico*. Washington, D.C.: Library of Congress, 1979

1978 Albright, Thomas. "The Force of Universals." *Artnews*, Spring 1978

Atkins, Robert. "Revolt on Canvas." *Berkeley Barb*, March 14, 1978

Cancio, Maria I. "Artist Advocates Social Change." *Deadline*, July 1978

Catlett, Elizabeth. "Rupert Garcia," in *Rupert Garcia: Pastel Drawings*. San Francisco: San Francisco Museum of Modern Art, 1978

Frankenstein, Alfred. "When Politics and Art Do Mix." *San Francisco Chronicle*, March 15, 1978

Martinez, Sue. "Museum Exhibits Garcia Drawings." *El Tecolote*, April 1978

Orth, Maureen. "The Soaring Spirit of Chicano Arts." *New West*, September 11, 1978

1977 Frankenstein, Alfred. "A Long-Range View of Latino Art." *San Francisco Chronicle*, October 21, 1977

"Poster Art Reflects Ideology." *San Francisco Journal*, December 21, 1977

Rama, Angel. "El Arte de los Chicanos." *El Nacional* (Caracas, Venezuela), March 8, 1977

1976 Albright, Thomas. "San Francisco." *Artnews*, November 1976

Dunham, Judith L. "Art of Many Sources." *Artweek*, October 16, 1976

Gonzalez, Lila. "Ideas on a Third World Art Exhibit." *Odalisque*, October 14–November 13, 1976

1975 Albright, Thomas. "At the Galleries." *San Francisco Chronicle*, May 27, 1975

Arnold, Frank. "Posters and Society." *People's World*, January 11, 1975

Franco, Jean. *Juan Fuentes y Rupert Garcia: Posters-Drawings-Prints*. San Francisco: Galeria de la Raza, 1975

Luchetti, Kathy. "Four Artists and How They Make a Living." *San Francisco Bay Guardian*, October 3, 1975

Monteverde, Mildred. *Chicano Graficos: California*. Pueblo, Colorado: Southern Colorado State College, 1975

1974 Albright, Thomas. "An Art Show That Began with a Toilet." *San Francisco Chronicle*, December 21, 1974

1973 Albright, Thomas. "A Print Show—Tiny, but Solid." *San Francisco Chronicle*, December 19, 1973

1972 Ojeda, Jay. "Galeria de la Raza—Art for the Community." *San Francisco Progress*, March 24, 1972

1971 Monteverde, Mildred. "Contemporary Chicano Art." *Aztlan*, Fall 1971

1970 Albright, Thomas. "A Wide Range in Latin Art." *San Francisco Chronicle*, September 12, 1970

"Artes de la Raza." *Artweek*, September 5, 1970

1969 Clark, Jeff. "Student Art—'to be seen.'." *The Daily Gater*, November 1969

Ugarte, Abdon. "Poster de E. Zapata para el Publico." *La Prensa*, July 1969

By the Artist

1983 "Arte Mural del Movimiento Chicano," in *A Traves de la Frontera* (translated by CEESTEM). Mexico: Centro des Estudios Economicos y Sociales de Tercer Mundo, 1983. (Later published in *El Gallo Illustrado*, January 22, 1984. Sunday supplement of Mexico's *El Dia*.)

"Chicano-Latino Wall Art: The Mural and the Poster," in *The Hispanic American Aesthetic: Origins, Manifestations and Significance*, edited by Jacinto Quirarte. Austin, Texas: Research Center for the Arts and Humanities, University of Texas, 1983. (Published papers presented in San Antonio as part of the work of the Task Force on Hispanic American Arts carried out under the auspices of the National Endowment for the Arts.)

Frida Kahlo: A Bibliography and Bibliographical Introduction. Berkeley: Chicano Studies Library Publication Series, no. 7, University of California, 1983

1979 Introduction to *La Raza Silkscreen Center: Images of a Community*. San Francisco: Galeria de la Raza, 1979

"Murales recientes de 'La Raza' en estados unidos," (coauthored by Tim Drescher, translated by Rosamaria Nunez), *Plural*, vol. 8, no. 96, 1979

"The Mexican Movie Poster: Art, Myth, Illusion, Deception," in *Posters from the Golden Age of Mexican Cinema*. San Francisco: Galeria de la Raza, 1979

1978 "Community Art: Murals," in *Community Art: Murals*. San Francisco: Galeria de la Raza, 1978

"Pulqueria Art: Defiant Art of the Barrio, part two," *El Tecolote*, vol. 8, no. 5, 1978

"Recent Raza Murals in the U.S.," (coauthored by Tim Drescher), *Radical America*, April/May 1978

"The Politics of Popular Art," *Chismearte*, vol. 2, no. 1, 1978

1977 "Chicano Poster Art," in *Prelude to the Fifth Sun/ Traditional Chicano and Latino Art*. Berkeley: University Art Museum, University of California, 1977. (Interview of the artist conducted by Ralph Maradiaga.)

"Pulqueria Art: Defiant Art of the Barrio," *El Tecolote*, vol. 8, no. 4, 1977

"Snapshots of Aparicio," *SFA Eye*, vol. 6, no. 1, 1977. (Later published in *TIN TAN*, vol. 6, Fall 1977)

1976 Introduction to *Laminas de la Raza*. San Francisco, 1976. (Portfolio of black-and-white reproductions of works of art by San Francisco Bay artists.)

"Mexican Muralists and the School of Paris," *Left Curve/Art and Revolution*, Fall 1976

"Realismo Chicano," in *Juan Fuentes: Realismo Chicano*. Berkeley: Chicano Studies Library, University of California, 1976. (Notes for brochure.)

"Sources," in *Other Sources: An American Essay*. San Francisco: San Francisco Art Institute, 1976

"The State of Art in California: Breaking with Old Ideas," *The Arts Biweekly*, no. 39, December 15, 1976

1975 "Gilberto Ramirez Muralista Mexicano: hable sobre los murales y los muralistas en los e.u.," *El Tecolote*, vol. 4, no. 2, 1975

1974 "Alfaro Siqueiros," *El Tecolote*, vol. 4, no. 3, 1974

"Mission Muralist Off to Mexico," *El Tecolote*, vol. 5, no. 2, 1974

"The Mural Is Not for the Bankers. It's for the People." *El Tecolote*, vol. 4, no. 6, 1974

Raza Murals and Muralists: An Historical Perspective. San Francisco: Galeria de la Raza, 1974

1972 "An Historical Look at Raza Murals and Muralists," *El Tecolote*, vol. 2, no. 14, 1972

Lenders to the Exhibition

Amalia Mesa-Baines and Richard Baines, San Francisco
Mr. and Mrs. Fred Banks, San Francisco
Franklin Scarlata Dental Corporation, San Francisco
Sammi Madison-Garcia and Rupert Garcia
Harcourts Gallery, San Francisco
Dr. John C. Kennady, Fountain Valley, California
Dr. William H. Kroes, Los Angeles
James Bell and Francesca Lewis, San Francisco
Robert Marcus, San Francisco
The Mexican Museum, San Francisco
Dennis Miller, Sanibel Island, Florida
National Museum of American Art, Smithsonian Institution, Washington, D.C.
The Oakland Museum
Gertie and Harold A. Parker, Tiburon, California
David and Janet Peoples, Berkeley
Jeffrey S. Pollak, San Diego
Mr. and Mrs. Edwin Raskin, Nashville
San Francisco Museum of Modern Art
Peter and Carole Selz, Berkeley
Shelves and Cabinets Inc., San Diego

The Mexican Museum

Board of Trustees

Fernando de Necochea, President
Cynthia Vargas, Vice-President
Ruben Garcia, Treasurer
Ann Barrios, Secretary
Anne Kohs
Aminta Moss
Emilio Nicolas, Jr.
Marilyn Sode Smith
Leandro Soto

Peter Rodriguez, Founder and Board Consultant

Staff

David J. de la Torre, Executive Director
Lee Barish, Development Assistant
Rudy Barrientes, Preparator
Carmen Carrillo, Museum Aide
Peter Coquillard, Preparator
Alida Francis, Museum Aide
Lorraine Garcia, Development Director
Alfonso Gonzalez, Museum Aide
Blanca Flor Gutierrez, Administrative Assistant
Beatrice Carrillo Hocker, Associate Curator of Education
Gloria Jaramillo, Registrar
Bob Jones, Preparator
Aini O. Karkiainen, Bookkeeper
Norma Villaluna, Museum Aide
Nora E. Wagner, Curator of Education